9.9e

CAPTURING THE LIGHT
IN PASTEL

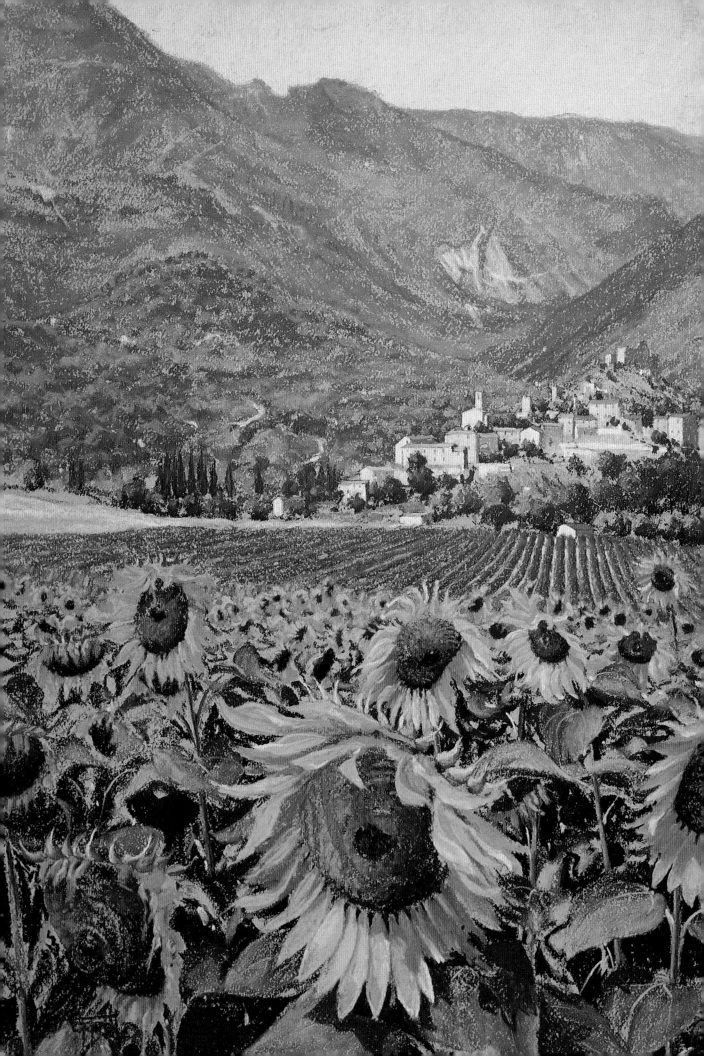

CAPTURING THE LIGHT
IN PASTEL

Lionel Aggett

David & Charles

A DAVID & CHARLES BOOK
Copyright © Lionel Aggett 1995
First published 1995

A catalogue record for this book is available from the British Library.
ISBN 0 7153 0221 3

Designed and typeset by Cooper Wilson Design
and printed in Singapore by C S Graphics Pte. Ltd.
for David & Charles, Brunel House, Newton Abbot, Devon

DEDICATION

To my wife Anne, to Russell and Kate and in memory of my parents who are no doubt up
there watching their son doing what he likes best. Also Fudge, our characterful cat (the
inspiration for many of Anne's paintings) so sadly run over and killed two weeks before the
completion of this book.

ACKNOWLEDGEMENTS

I would like to thank my editor, Alison Elks, for her help and advice; Tricia of A M Micro,
Exeter, for producing the typescript recorded from my longhand; Martin Chambers of
Studio 4, Exeter, for photographing the final stage of the demonstration paintings and some
of those used as examples; John and Kate Hersey for providing photographs of their excellent
pastels; Jillian Llewellyn Lloyd of Llewellyn Alexander (Fine Paintings) Ltd, for loaning six
transparencies (also taken by Martin); the owners of paintings who kindly consented to their
use; my brother Reginald for his meticulous framing that both complements and protects my
work; and finally Anne for her patience and encouragement over these past few months.

AUTHOR'S NOTE

I do not fix my paintings when completed, for the effects of light would be dulled through the
coalescence of the pastel particles. All the illustrations are therefore reproduced from trans-
parencies taken by myself with the exception of those photographed by Martin Chambers.
This introduction of a further stage in the reproduction process will no doubt have affected the
final colour to some degree, and I hope the reader will accept any slight disparity.

HALF TITLE **Autumn Prelude, Southernhay, Exeter.**
12¾ x 9¾ in (32.5 x 25cm). *Private collection*

TITLE SPREAD **Sunflowers and Lavender, Provence.**
22 x 30 in (55 x 75cm). *Private collection*

CONTENTS

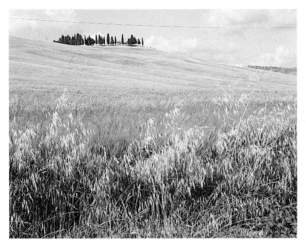

Val d'Orcia, Tuscany.

Val d'Orcia, painting in progress.

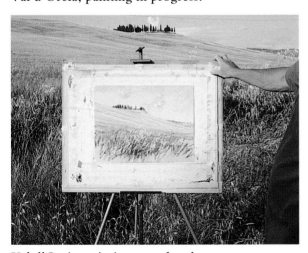

Val d'Orcia, painting completed.
12¾ x 17 in (32.5 x 43.5cm).

INTRODUCTION

Light enables us to see colour. The quality or nature of light affects the colour we see. Through an understanding of light we can learn to capture on canvas those qualities which determine the character of a particular place, region and, on a larger scale, country or continent. Of course, geographical, geological and climatic conditions impart a physical influence upon local agriculture, industry and architecture, and in turn these man-made creations influence the form of our landscape. However, the character of a place or scene is ultimately defined, and enhanced, by the ever-changing light.

The ultimate challenge presented by Nature to the artist is to capture and interpret in his or her own style the character of a particular region. To do this successfully requires an understanding and appreciation of the correct rendering of colour and the way it is influenced by the quality of light. I believe a 'sense of place' is important, and whilst accepting that the urge to shock can sometimes produce exciting discords, a landscape painting should leave the viewer with no doubts as to where, when and under what conditions it was created. This is a personal viewpoint perhaps, but I regard with dismay works depicting grey-green 'maritime climate' landscapes using a palette more suited to the Mediterranean. Learning how to first

Oppède le Vieux, Provence.
9¾ x 12¾ in (25 x 32.5cm).

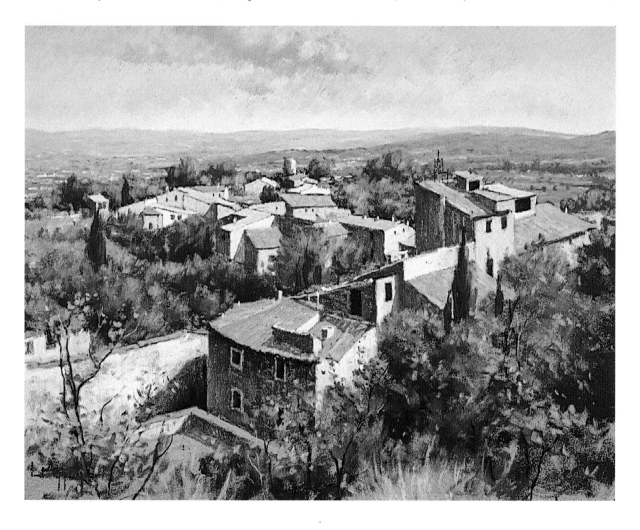

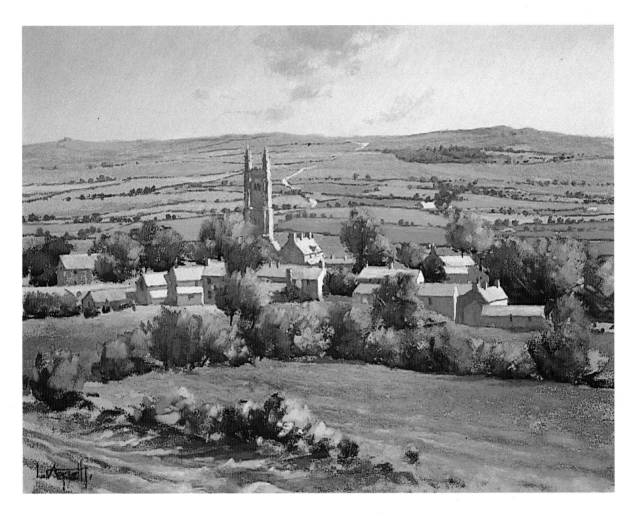

Widecombe, Dartmoor.
9¾ x 12¾ in (25 x 32.5cm).

observe and then adapt and use your palette to capture constantly changing light and colour will give your work a truer relationship with Nature. I hope that this book, through exploring and appraising the many influences affecting the quality of light, will assist in developing a wider appreciation of such truth.

The reference to a 'personal viewpoint' acknowledges the fact that some artists deliberately distort and reverse natural colour arrangements, sometimes ignoring base values altogether in order to create exciting effects. This is sometimes referred to as the use of expressive rather than naturalistic colour. This is fine, but my belief is that landscapes, and indeed all subjects, should be approached with truthfulness before the rules are broken or bent; there is still plenty of scope for the development of personal style.

About two-thirds of the effort that goes towards the execution of a painting can be attributed to observation. By constantly watching the effects of light falling on both the land-

scape and objects within it, we can, over time, build up a store of information. Try never to be without a sketch book; if one is not to hand then produce a 'mind' sketch. Study the scene and run through the process of recording it. Don't ignore this useful technique of increasing your powers of observation.

My knowledge and competence, such as it is, has developed chiefly through observation and experience based on a natural efficacy for art given to me by my parents (for which I am eternally grateful). My comments are my own, for I am neither a qualified teacher nor have I been to art college, although I did study art and the history of art and architecture while qualifying for the Royal Institute of British Architects. There is no doubt that the disciplines of application and observation thus learned have assisted me in my current occupation as a full-time artist.

As rather 'contrived' examples of poor observation, the two paintings on pages 6 and 7 express the use of inappropriate palettes.

The lovely village of Oppède le Vieux (page 6), being restored in the Petit Lubéron, provides a well-structured composition under the blue Provençal sky. The palette chosen for the subject has not, however, met the challenge presented by the intense hot and burnt colours of the region illuminated by the vibrant clear light. Blue, grey-greens and purple-greys perhaps more suited to Dartmoor fail where blue-violets abound. Interestingly, the painting captures some of the Provençal character even though the palette is entirely wrong for high summer in that region.

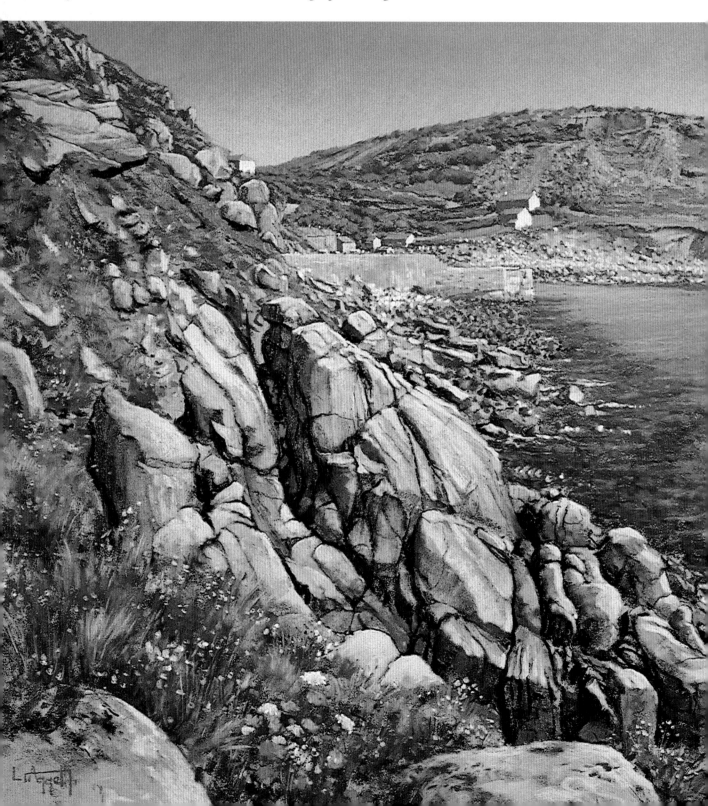

RIGHT **Plockton, Western Highlands, Scotland.**
21¾ x 29½ in (55 x 75cm).
Private collection

BELOW **Lamorna Cove, Penwith, Cornwall.**
19½ x 25½ in (50 x 65cm).

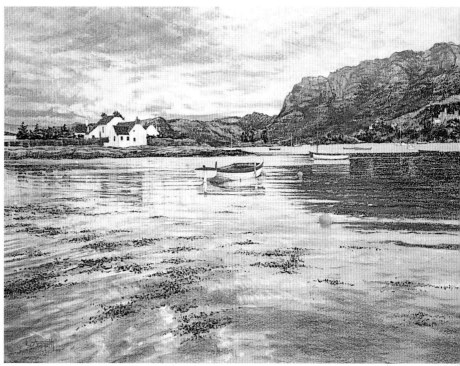

The painting of Widecombe (page 7) is perhaps attractive, but this oscillating rendering charged with strong colour combinations surely has no place under the softly lit skies of Dartmoor. There is no 'sense of place', for the painting certainly does not evoke that mysterious feeling which the moor seems to possess whatever the time of the year.

To earn a living solely through painting requires both application and self-discipline. An architect would incur the client's wrath if contracts were delayed because the creator was waiting for divine inspiration! Similarly and against popular belief, professional painters cannot sit about waiting for the right vibes to kindle their creative imaginary senses. Those who can afford such a luxury usually have some other form of income. There is no substitute for continual hard graft during which there will be peaks and occasional lows, for we are human after all.

My decision to give up architecture was made because it is virtually impossible to give serious attention to both occupations at the same time. Having reached a stage where I had completed several interesting architectural projects I felt the need to concentrate entirely on fine art. I also found that cutting off one's salary lifeline concentrates the mind wonderfully!

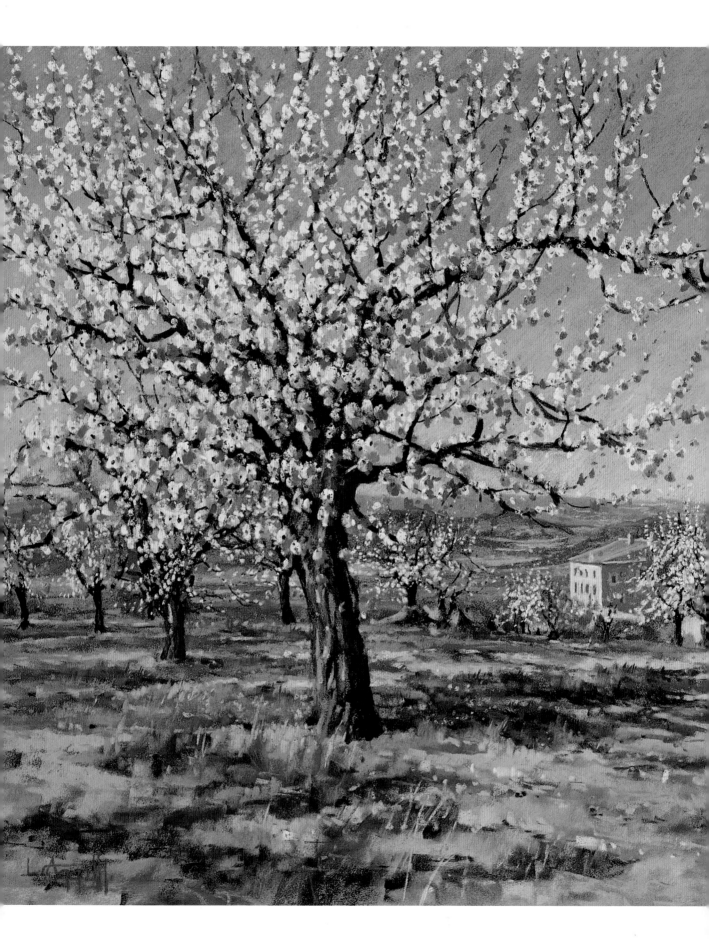

Unlike my earlier book on pastels★ intended for comparative beginners, this book is slightly more advanced. Most of the paintings are complete works executed in my personal style. There should, however, be something for everyone, hobbyist or professional; the contents of this book may even be viewed simply as a celebration of light.

There are certain regions that are renowned for their quality of light. Those to which I have so far been attracted are featured in these pages. I shall therefore be introducing you to some of my favourite and most evocative haunts: when you have worked out of doors, each painting becomes an experience through observation. Regional differences in subject matter and the many conditions which affect the light playing on the landscape and subject matter are explored further in the following chapters.

The two paintings of Plockton and Lamorna Cove both express conditions of light and location. In the painting of Plockton (page 9) the clear light of the western coast of Scotland is somewhat diffused by an almost completely overcast sky. A study in subtle greys, light plays an important part in this painting. The colour of the sky is reflected in the distant landscape and water. Warmth is provided where the light from the lowering sun strikes the top of the mountain range.

West Cornwall, on the other hand, is an area renowned for the vibrant quality of its light. In the painting of Lamorna Cove (page 8), however, the vibrancy is tempered by the haze so often experienced in this region. Nevertheless, there is a clarity in the colour of the water and reflections, and the strongly defined granite cliffs.

The region which became the theme of my first London show, Provence, has long been the source of sun-bleached landscapes where the vibrant light can either over-work or reduce the tension in the optic nerve. Not a medical observation but just a simple response to the magnitude of difference between the conditions experienced near the Mediterranean and Britain's maritime climate. Some require sunglasses to

★*Pastel Techniques* (Crowood Press 1992).

RIGHT **Cherry Orchard, Bonnieux, Provence.**
19½ x 25½ in (50 x 65cm). *Private collection*

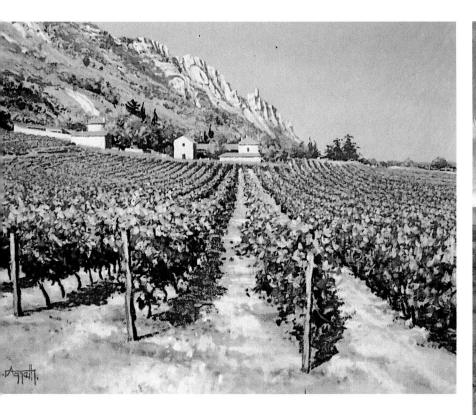

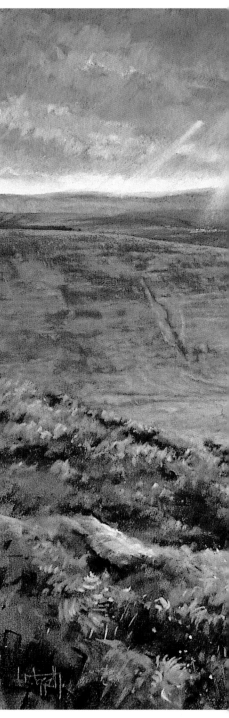

reduce the glare, whereas I find I can read clearly without my bi-focals – a verification of the clarity to be found there.

We have visited the area at all seasons apart from winter. *Cherry Orchard* was executed on the spot during our last spring visit in our travelling studio, a VW Camper.

Painted on raw sienna Rembrandt board, the painting evokes the clear brilliant quality of Provençal light. Not so intense as the later summer emissions, the spectrum is bounced back and forth between the trees in this orchard in a profusion of subtle colours to be reflected by the huge blossom. Blue-violet/yellow-gold and red-earth/green combinations heighten the effect of scintillating light.

Instead of taking the N7 or A7 motorway down the east bank of the Rhône, I can recommend a slower excursion down the west road (N86) taking in some old and rather dilapidated but nevertheless interesting villages.

In this painting of a vineyard on the west bank of the Rhône, clear light bounces off everything. The violet-blue of the sky is deflected by the distant hills and by the overturned leaves of the vines. Reflected light from the sun-baked earth rebounds on to the under-

ABOVE **Towards the Warren House Inn from above Grimspound, Dartmoor.** 19½ x 25½ in (50 x 65cm).

TOP LEFT **Côtes du Rhône.** 9¾ x 12¾ in (25 x 32.5cm). *Private collection*

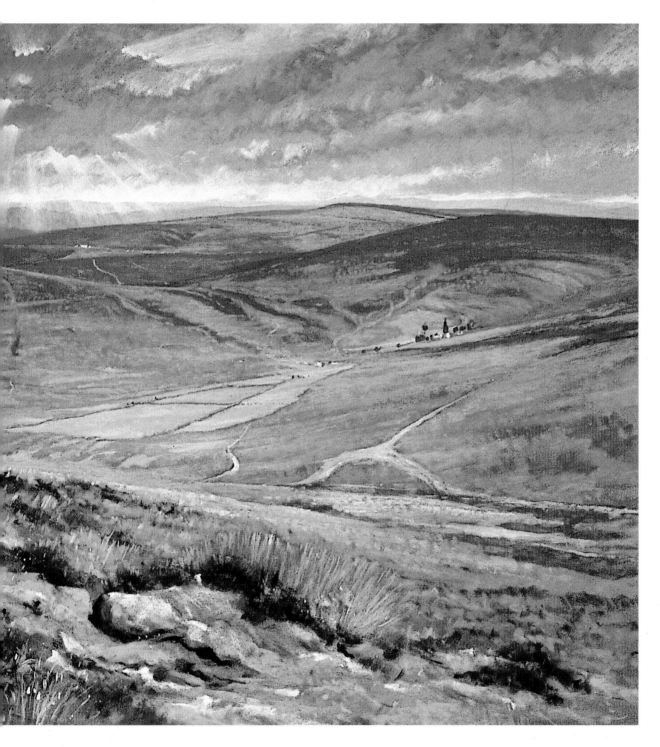

side of the vines. Blue-violet abounds to form the basis of a lively palette.

In complete contrast to the Côtes du Rhône scene the view on Dartmoor vindicates the need to select the correct palette. Whereas the vineyard painting comprises a range of hot blue-violets and red and brown earth colours, this subject calls for an approach much lower in key. A mixture of cool and warm purple-greys have been used for the overcast sky. These colours are reflected in the landscape where grey-greens and purple-greys predominate, relieved by the subtle warm colours of grasses, bracken and heather. Both subjects have been firmly placed in their region of origin and depict the conditions under which they were perceived.

Chapter 1
PASTELS AND PAPERS

··

PASTELS

Before proceeding any further it would seem sensible to discuss briefly the materials that are available to the pastel artist. There are many magazines that do a splendid job by continually updating the artist with regard to what is new, something a book cannot do. I will therefore deal solely with the pastels I use and the papers/supports I have tried.

I have tried several pastels (Rowney, Schmincke, Rembrandt, and Sennelier) but for the past six years I have used solely Unison Colour Soft Pastels. Their range of colours and the manner in which they are arranged is entirely in harmony with my approach.

Unison Colour was founded in 1987 by John Hersey after a long enquiry into the resonance and harmony of colour. From their workshop in the hills of Northumberland the pastels are sent

LEFT There are nine basic colours in the Unison range, 27 additional colours. The nine are red, red earth, yellow-gold, brown earth, green, green earth, blue-green, blue-violet, and grey. Each is available in a set of 18 harmonic blends. They are grouped in pairs as a movement around a centre of intense sunlight and can be seen as separate colours, and as a unity, a unison. The pastels are numbered 1–18 in each box for re-ordering.

BELOW RIGHT The pastels are made in two sizes, standard (2¾ x ¾in/7 x 2cm) and small (2 x ½in/5 x 1.5cm). There is also a giant size (3½ x 1½in/9 x 4cm).

BELOW LEFT Unison Colour will supply hand-drawn charts giving the precise hue. The pastel marks are made on Canson Mi-Teintes 407 (reverse face). The example shown here is blue-violet, with the colour's numbers, and arranged as they are presented in the box.

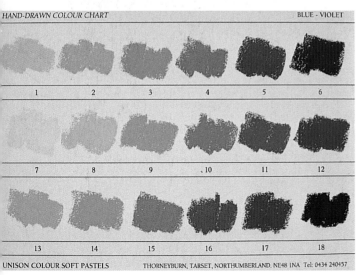

HAND-DRAWN COLOUR CHART BLUE - VIOLET

1	2	3	4	5	6
7	8	9	10	11	12
13	14	15	16	17	18

UNISON COLOUR SOFT PASTELS THORNEYBURN, TARSET, NORTHUMBERLAND. NE48 1NA Tel: 0434 240457

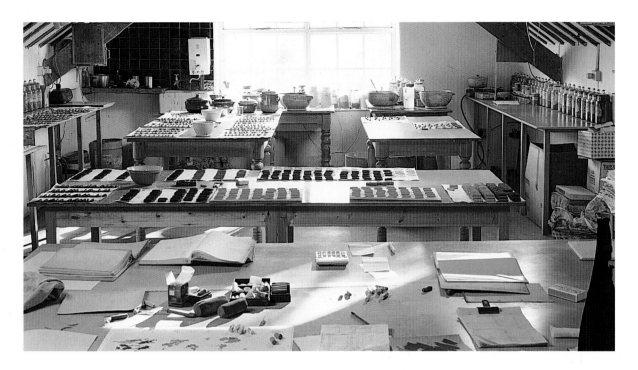

to artists throughout the world, as well as to wholesale distribution centres and shops in Great Britain and continental Europe.

They offer over 200 colours, grouped into a series of colour-integrated sets, though naturally all colours are available from other suppliers too. The range is not made up, as is usually the case, by the simple – and mechanical – addition of either black or white, a process which results in a whole series of stepped reductions or tints, having no reference to the whole. Instead, Unison took a colour and saw how it might explain itself as light, in relation both to its intensity and to the endless play of other colours. In this way the colour relationships became cyclical, as they are in Nature.

Colour, for the artist, is commonly used to illustrate a recognizable world of separate objects more or less skilfully. But to the eye, light itself is the real beauty of the world, making colour the tangible evidence of the whole creation. This holistic point of view can, naturally, have a far-reaching influence on the way that we see our surroundings, and it is from this standpoint that Unison Colour Soft Pastels are developed.

Having all the traditional fluency of the medium, the pastels are handmade in three sizes: small, standard and giant. They are more robust than most ordinary pastels, making them longer lasting and much more economical to use.

A view of John and Kate Hersey's studio at Thorneyburn, Tarset, Northumberland, showing a batch of newly made pastels laid out for final finishing prior to packing and despatch.

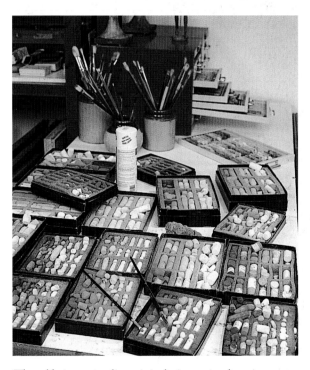

The table in my studio as it is during a pastel session; note the two sizes in use. Pastels may be kept in the boxes provided (as here), or in a cabinet, useful for storage of replacements. The red index cabinets (seen to the rear) contain other pastels.

PAPERS

The choice of papers and supports is now very wide. Most are available in a generous range of colours. My advice is to try as many as you can until you find the texture which suits your individual approach best. Colour and tone should be selected with the subject matter in mind, for it makes sense to make the paper work for you rather than against you. Generally speaking this means choosing a paper to match the mid-tone of the subject with a colour to correspond with the mood or temperature.

Paper weights are designated in grams per square metre (gsm). The heavier papers (ie 160gsm) will withstand rough treatment rather better than the lighter weights and do not need

Canson Mi-Teintes 354 (blue-grey) – front face.
This paper possesses quite a heavy texture, not unlike a rough canvas. It is available in 35 numbered shades. Weight 160gsm.

Canson Mi-Teintes 340 (warm buff) – rear face.
The same paper but a different colour and as you can see the reverse side has a pleasant fairly even texture. The paper is light fast.

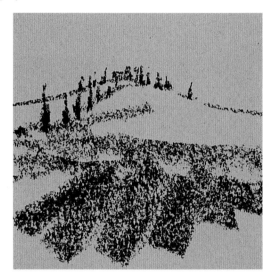

Velour paper.
A synthetic flock paper. The texture is quite velvet-like and will accept the subtlest of touches. The surface will also respond to the firmly applied pastel stroke.

Watercolour paper.
Available in so many textures, watercolour paper can be tinted with a wash of watercolour or acrylic to match the colour, mood, temperature and tone of your subject.

to be mounted when used for paintings of 8¾ x 12¾ in (22.5 x 32.5cm) or smaller. Above this size all papers should be mounted to prevent unsightly cockling.

Most of the paintings in this book have been executed on either Rembrandt board or on Canson Mi-Teintes paper. These are the supports I currently use most. The two papers are shown on these two pages together with other papers I have tried. These are all of good quality, and according to the manufacturers' information are light fast.

The texture of the support can be emphasized or reduced in effect, according to the backing you are working on; for example, glass will enhance texture, whereas two layers of paper between support and board will tend to 'hold back' the texture.

Fabriano, Tiziano.
A well-sized high-quality paper having a cotton content of 40 per cent. The colour illustrated is no 25. It is available in 31 numbered colours that are resistant to fading. Weight 160gsm.

Rembrandt board.
This board is faced with an abrasive coating of pumice which gives an even tooth. It is available in 14 colours; the board illustrated is in raw sienna.

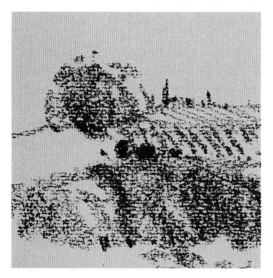

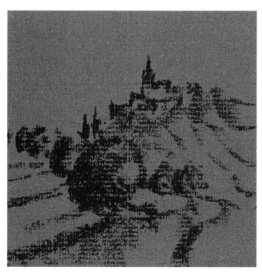

Fabriano Ingres.
Colour fast, and available in 18 numbered colours, this paper possesses an instantly recognizable horizontal texture. Weight 160gsm. Colour illustrated: no 707.

Cabinet paper.
This paper, used on pages 96 and 97, and other glass-papers provide quite reasonable textures although I found this to be a little harsh compared with the softer pastel papers.

Chapter 2
THE APPLICATION OF PASTEL

..

Pastel, being a dry medium, is ideal for capturing the sometimes fleeting effects of light both in the plein air manner and in studio work.

The four basic pastel marks can be used in their own individual ways to capture light on the support, but the combination of three marks blended and laid side-by-side usually produces more resonant work. This is how I prefer to paint, for my personal view is that the first approach generally leads to a rather exaggerated and mannered work (with the exception of 'line' which is essentially a drawing technique). The way is open, however, for each of us to experiment and develop in our own way.

...

COMPOSITION

...

The initial composition of the painting is often registered using the line stroke (demonstrated below). This can be achieved with a medium-toned pastel, Conté pencil or charcoal. Always use a fixing medium over heavily applied charcoal to avoid the lighter charcoal dust being lifted by the heavier pastel, so darkening the pastel's colour.

...

THE LINE STROKE

...

The line stroke is of course a drawing technique. It is capable of producing the most expressive of marks through variation of pressure and the change in the angle of the pastel stick whilst delivering the stroke. The stick can be induced to self-sharpen during the course of a stroke by rotating slowly against the 'cutting edge'. This is a draughtsman's technique for keeping the pencil sharp when working on the drawing board. The simple demonstration below shows the expressive possibilities of the line stroke. The basic movement (top left) shows how the line becomes thicker without applying added pressure, but by holding the stick steady between thumb and index finger throughout the stroke. By rotating the stick against the cutting edge (centre) a line of even width can be maintained. By adding pressure at given points to a combination of these two movements, lines of a direct expressive nature can be achieved to indicate form, light and shade. Cross hatching can be used to further emphasize form and blend colours.

Colle di Val d'Elsa is a rapid sketch made with a red earth 6 pastel on the reverse side of Canson Mi-Teintes 340 warm buff paper. There has been no attempt to record any detail of this stunning hill town not far from San Gimignano. Expressive line, sometimes broken, simple block and cross hatching

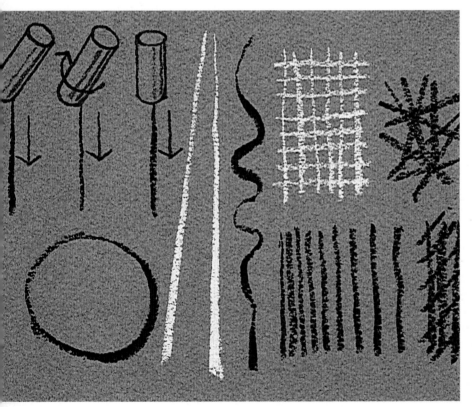

and variation of pressure suggest distance, perspective, form and the interplay of light and shade.

The study of a vineyard on the outskirts of Siena (bottom) shows how line strokes have been used to blend colours and accentuate the source of light (the sun). Medium-length (½ in/1.5cm) strokes of yellow-golds, reds, blue-greens and blue-violets radiate away from the sun, out of picture, some side-by-side and others overlapping. The yellow-violet and red-green combinations thus laid resonate to suggest intense sunlight. Longer expressive line strokes form the vines and short strokes combine to indicate foliage. Further yellow-violet, blue-orange and red-green passages registering the church, olives, vines, grasses and poppies produce a painting full of shimmering light.

LEFT **Colle di Val d'Elsa, Tuscany.** 9¾ x 12¾ in (25 x 32.5cm).

BELOW **Vineyard, Siena, Tuscany.** 9¾ x 12¾ in (25 x 32.5cm).

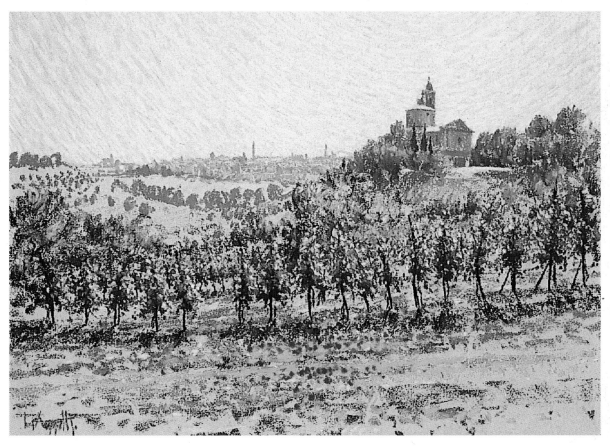

THE FLAT STROKE

This stroke or mark can be used to cover large areas with pigment. It is also useful where a certain amount of blending is required, for example, when painting clouds. It can also be used to achieve direct, lively effects by laying flat areas of colour side-by-side, without blending. It is, however, more generally used together with other marks when blending colours directly on the textured support.

The illustrations here demonstrate how to apply the flat stroke and integrate it into your work.

The illustration below shows how to use pastels to produce flat strokes in various forms. Hold a piece of pastel approximately ½ in (1.5cm) long between the side of the pastel and the surface of the support. Drag downwards and the texture of the support will be revealed. Drag sideways and circular movements can be made to produce expressive marks. Tonal expression can be introduced by increasing or reducing pressure during the course of the stroke. Further variation can be achieved through increasing the pressure at one end of the stick during vertical or diagonal strokes.

ABOVE RIGHT A simple design produced with direct flat strokes and a small amount of blending in the sky and lavender. The 'flying cylinders' indicate the direction in which the pastel strokes were made.

RIGHT **Olive Trees and Poppies below San Gimignano, Tuscany.** 9¾ x 12¾ in (25 x 32.5cm). *This lively sketch was produced almost entirely with flat strokes. A clear, shimmering sky was depicted through diagonal strokes placed side-by-side and partially overlapped where blending, using varied pressure throughout the strokes and to one side of the stick. The towers and lower buildings of the town were pastelled with strokes following the form of the building, for example vertical strokes for the walls and sloping strokes for the roofs. The foliage was applied with crisp, directional flat strokes and the grasses with long and short strokes (according to perspective). Orange-blue, violet-yellow and green-red colour combinations add to the vibrancy of this composition.*

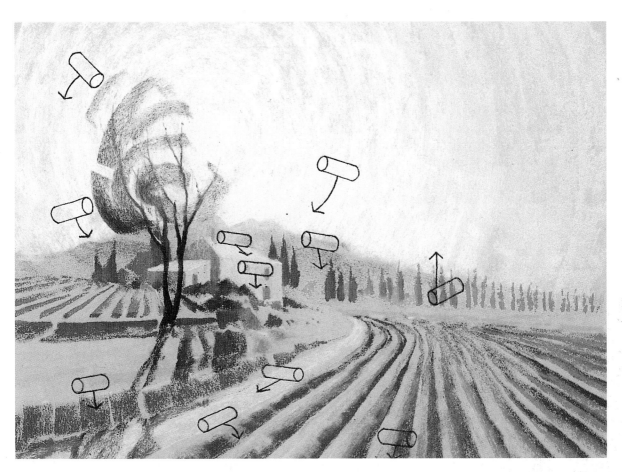

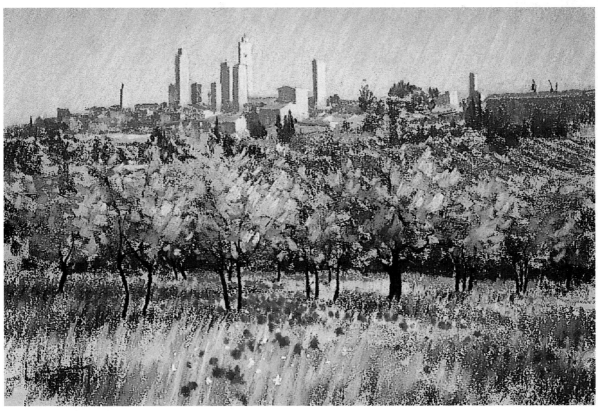

THE POINTILLIST STROKE

Pointillism is a technique first developed by the Impressionists to convey the sense of light and movement in their paintings. The technique comprises a series of dots or small marks made with the end of the pastel stick. The colours used were usually complementary to one another to heighten the drama. Seurat's paintings were composed entirely of small dots. Other artists used short and varied small marks in the quest to capture light, Monet, Pissarro, Van Gogh and Renoir among them. The latter used pastel, as indeed did Degas.

As with all pastel shades, a change in intensity is achieved through variation in pressure. In the illustration below, a sharp twist with the end of the stick has produced a mark of extreme intensity. An extension of the 'dot' thus formed is the short stroke (left). A combination, with the short strokes made in various directions, can be very effective.

A feeling of perspective can be achieved through variation of dot size and the spaces in between (centre). Colours can be blended by placing the dots side-by-side and overlapping them. Yellow and red blend to produce orange; the blue complementary makes the mixture sing (right).

The painting opposite of a field of poppies just outside Penzance in west Penwith, Cornwall, suitably illustrates the use of dots and small strokes to produce the effect of dancing light. The clear light of the area draws me there to paint every year. I have used the pointillist stroke more than I would usually for such a scene but the result is reasonably pleasing, the marks in the sky echoing the poppies. Some of the strokes in the sky are blended, others are placed side-by-side to depict vibrant light. Note the change in size of the strokes – to achieve perspective.

The painting *Cherries in Full Bloom*, capturing the early evening sunlight, was painted using a variety of strokes, but the pointillist mark dominates in the form of blossom. The blooms are not 'white' but a myriad of subtle reflected colours, some blended and others placed side-by-side.

OPPOSITE ABOVE **Penwith Poppies.**
9¾ x 12¾ in (25 x 32.5cm).

OPPOSITE BELOW **Cherries in Full Bloom, below Venasque, Provence.**
12¾ x 17in (32.5 x 43.5cm). *Collection of Mr and Mrs R Smith*

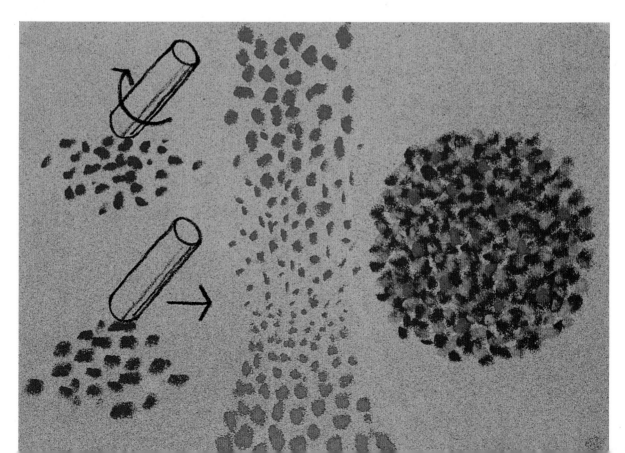

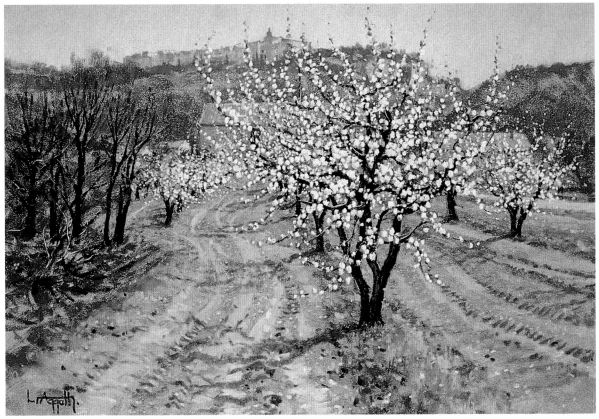

BLENDING

The previous sections illustrated blending through overlapping strokes and placing them side-by-side. More subtle and delicate blending may be achieved by rubbing overlapped strokes with the finger, tissue paper, cotton wool or the traditional torchon.

I prefer to blend by superimposing one colour over the other, easing the stroke into the existing colour. When some strokes are left following the direction of the form you are painting, for instance clouds, the effect is lively, natural and, above all, realistic.

In the illustration below, on the left, three colours were pastelled with crisp downward overlapping flat strokes. These were then blended with a finger (much cheaper than cotton wool or torchon). The cloud form on the right was blended with flat strokes against a blue sky blended in the same way.

The view opposite of a Norfolk landscape, located in a county renowned for its clear light and huge skies, was painted to the north-east of Norwich. The large climbing cumulus congestus clouds towering above a flat, darkened base echo the flat landscape. This painting clearly illustrates the technique of blending by overlapping strokes. The clouds, trees and grass were all blended in this way. The clouds form a major part of the painting, and send large, sprawling shadows across the fields, relieved by areas of sunlight which have been used to highlight the sheep, sails, and dilapidated mill.

The view *Spring Pasture* was painted on raw sienna Rembrandt board. It is a good example of subtle blending. The sky was blended solely with overlapping flat strokes using several colours: blue-violets, blue-greens, yellow-golds and reds. This scene would look quite different a month or two later with the sheep moved to higher pastures and the landscape baked and bleached by the sun.

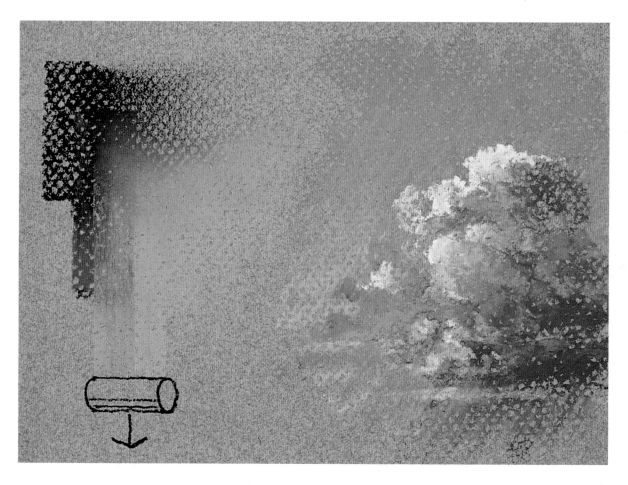

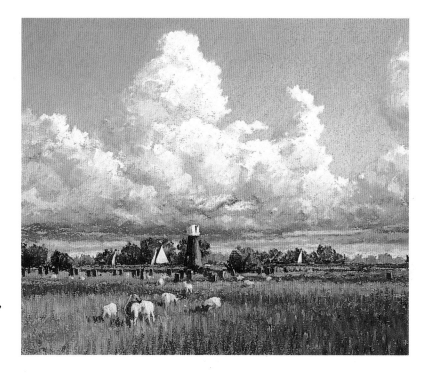

RIGHT **Norfolk Landscape.**
9¾ x 12¾ in (25 x 32.5cm).

BELOW **Spring Pasture, Eygalières,
Les Alpilles, Provence.**
9¾ x 12¾ in (25 x 32.5cm).
Private collection

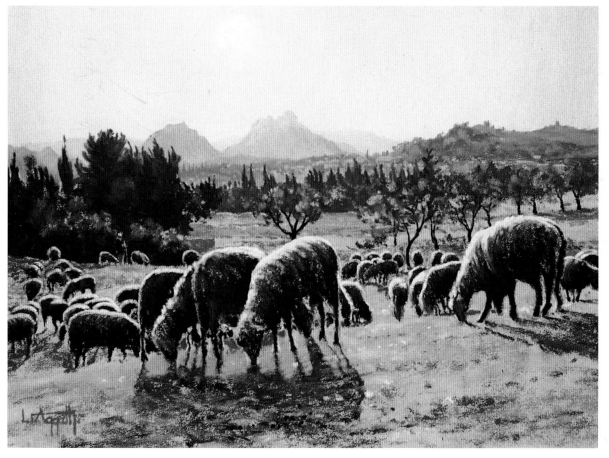

Chapter 3
NATURAL LIGHT

· ·

The chief natural light source is, of course, the sun. Other sources which emit light from the sky in varying degrees are the moon, stars, aurora borealis, and lightning. Fire we can refer to as a localized natural light source.

Light from the sun or any source is propelled by energy to bounce off the landscape and the surface of objects within the landscape to enter our eyes. It is then transferred to the brain which interprets the visual sensation as colour. 'White' light was discovered by Isaac Newton to break down into a spectrum of colours (colours of the rainbow), red, yellow, green, blue and violet. The colour we see is that which has been rejected by the object reflecting the light, whilst it absorbs all the others. Hence when we see a red poppy it is because the bloom has absorbed yellow, green, blue and violet, and rejected the red.

Although pastel colours are available ready mixed, a considerable amount of mixing and blending is carried out on the support whilst painting. Here we should remind ourselves that in mixing colours (subtractive colour mixing) the greater the number of pigments blended and mixed, the more light is absorbed and the resultant colour is darker. Red + yellow + blue = black. The mixing of the colours in the colour spectrum (additive colour mixing) combine to produce white light – the opposite of the theory of subtractive colour mixing. What we learn from both theories is that there is no colour without light, and no light without colour.

The light emitted from the sun is intense, its surface temperature being approximately 6,500°C. Just how intense depends on our loca-

BELOW **Newlyn Old Quay, West Penwith, Cornwall.**
9¾ x 12¾ in (25 x 32.5cm). Grey Rembrandt board.

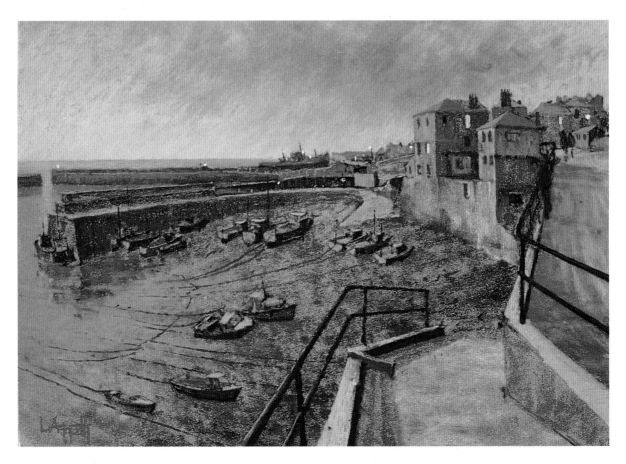

tion, ie whether the sun is high overhead or lower in the sky. The position of the earth is not fixed and therefore light and colour are continually on the turn. There are also many other factors which influence the quality of light illuminating the landscape. Many, if not all, will seem quite obvious but it is not perhaps until we stop and consider them all that we will appreciate fully the effect they have on the character, mood and colour of our surroundings.

There is no substitute for personal observation and it is hoped that the following chapters will help to increase the powers of even the more experienced artist.

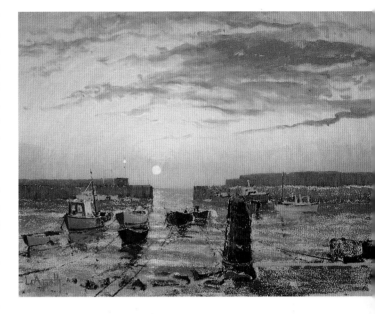

TIME OF DAY

As the sun moves across the sky the quality of light changes too. Although other factors cast their influence there are certain characteristics which are fairly consistent, ie they recur at a particular time of the day subject to seasonal change.

DAWN

The rendition of Newlyn Old Quay at dawn is a low-key painting appropriate to the amount of light emitted from the sky. Unsaturated (shaded) colours radiate away from the centre of each Unison Colour arrangement used; brown earth, red earth, green, yellow-gold and grey.

SUNRISE

In the Mousehole picture, a high autumn tide is shown at sunrise with sufficient sunlight to bring a few more colours to life compared with the Newlyn scene. Shaded blue-violets, blue-greens, yellow-golds, reds, red earths and grey were used.

MORNING

The cherries were painted one morning just a few yards from our VW Camper in the campsite at Bonnieux. The clear spring light, with the sun already hotting up, sings through this subject. The light is strong enough to bring the early spring colours bouncing around the orchard.

TOP RIGHT **Mousehole Harbour, Penwith, Cornwall.**
9¾ x 12¾ in (25 x 32.5cm).
Grey Rembrandt board.

LEFT **Cherries below Bonnieux, Provence.**
21¾ x 29½ in (55 x 75cm). Canson Mi-Teintes 340 (rear face) paper.
Private collection

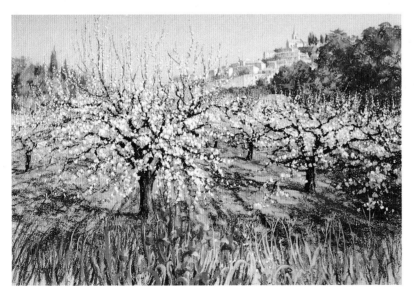

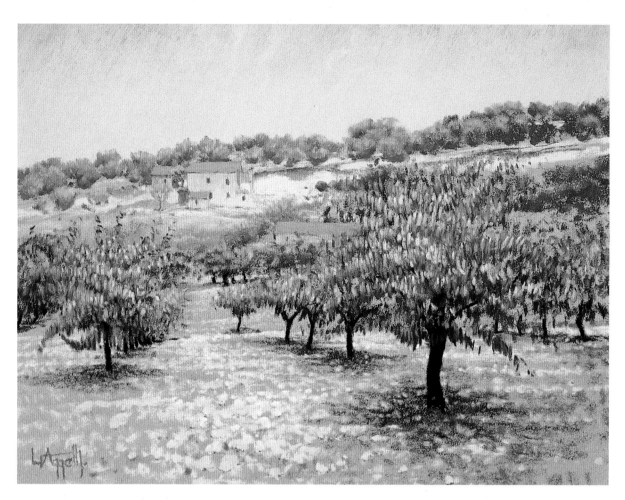

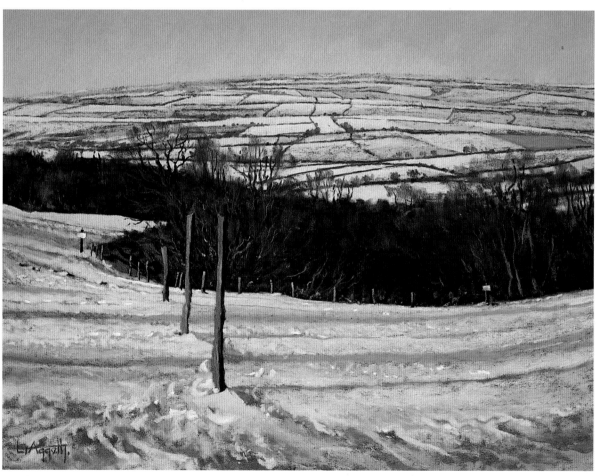

MIDDAY

At midday the overhead sun beating down on the baked soil and burnt grass of Les Alpilles (left) provided very little shadow to define shape. The sun's intense ultra-violet light seems to have bleached the surfaces, the spectrum being reflected to the extent that very little colour is released. The buildings and rock face merge through lack of definition (through shade).

TOP LEFT **Almond Trees, Les Alpilles, Provence.**
9¾ x 12¾ in (25 x 32.5cm).
Raw sienna Rembrandt board.

BOTTOM LEFT **Winter Shadows, Posbury, Devon.**
Raw umber Rembrandt board. *Private collection*

BELOW **Pruning the Vines, Sablet, Provence.**
21¾ x 29½ in (55 x 75cm).
Canson Mi-Teintes 340.

AFTERNOON

The low winter afternoon sun striking long shadows across the snow at Posbury Clump (below left), within view of my studio, contrasts with the previous painting, not only climatically but more importantly through the change in elevation of the sun. The warm colours contrasting with cool passages are released by the late afternoon sun. The almond trees and buildings in Les Alpilles would have looked quite different if painted four hours later.

EVENING

Sablet is one of four beautiful villages positioned along the western flank of the Dentelles de Montmirail to the west of Mont Ventoux. All are renowned for their wine which is produced from the oldest vineyards in France. In this painting, the lowering evening sun casts a warm glowing ochre light over the whole vineyard scene, producing subtle blue-orange combinations.

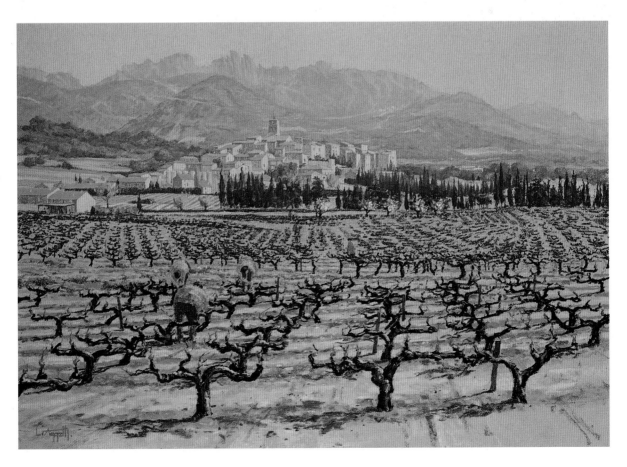

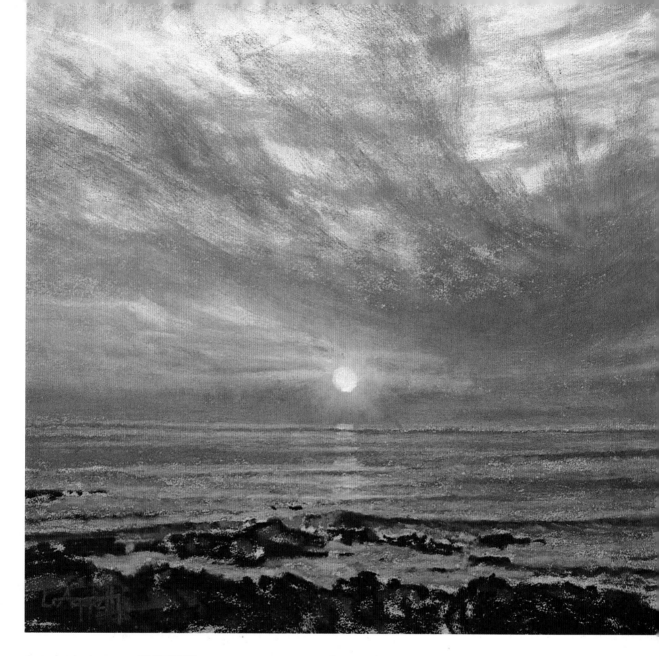

SUNSET

The Sennen study catches the sun just before it becomes even more filtered by the band of hazy cloud immediately above the horizon. The lower, darker thin and wispy cloud was blended across the higher cirrus with swift light flat strokes. Unsaturated (shaded) colours were used throughout the painting, the temperature of which is somewhat warmer than the sunrise at Mousehole (page 27).

DUSK

At dusk, caput mortem red Rembrandt board was used for the tranquil scene *Mousehole Harbour*, looking back at the village from the harbour wall. The last remnants of natural light are dissipated by cloud and any artificial lights begin to make their presence felt. Greys, brown earths, red earths, reds and yellow-golds were used, where the purple-grey-yellow combination produces low key contrast.

NIGHT

Even at night there is usually sufficient light to distinguish between solid and void, and certainly so when the moon is present. The coastal road from St Ives to Land's End is full of rugged beauty during the daytime. It becomes even more mysterious at night under moonlight when the landscape is enveloped with an eerie splendour. The view of *The Road to Morvah* required a very low-key painting. There is very little light to release the colours, and shaded earth reds and greys therefore predominate. The lights in the village sparkle against the purple-grey.

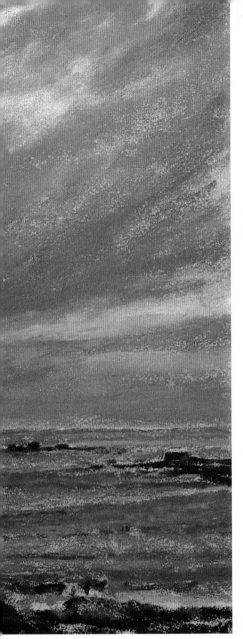

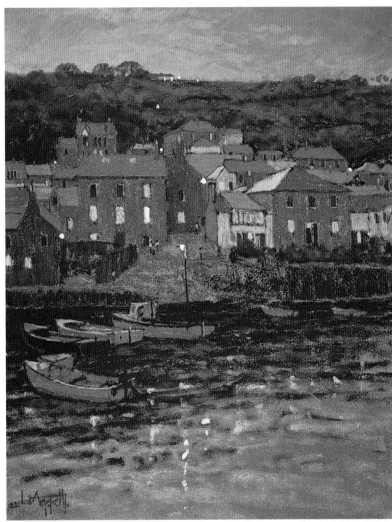

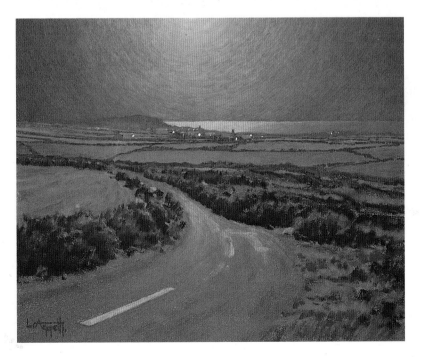

ABOVE **Sennen Sunset, Penwith, Cornwall.**
9¾ x 12¾ in (25 x 32.5cm).
Grey Rembrandt board.
Collection of Mr and Mrs E Grey

TOP RIGHT **Mousehole Harbour, Cornwall.**
9¾ x 12¾ in (25 x 32.5cm).

BOTTOM RIGHT **The Road to Morvah, Penwith, Cornwall.**
9¾ x 12¾ in (25 x 32.5cm). Caput mortem red Rembrandt board.

SEASONAL CHANGE

The position of the sun, and therefore the quality of light, is not only continually on the turn during the day, but throughout the year too, producing a climatic seasonal change. When combined with regional variations the number of lighting conditions we could potentially experience is enormous. Seasonal change in the landscape is the result of temperature change due to the variation in the intensity and quality of natural light. That is not to say we only use cool palettes in the winter, for after shedding her summer clothes Nature reveals rich warm colours which contrast with cool passages of light.

The illustrations in this section are, all but one, paintings of my native city of Exeter.

SPRING

During spring the gradual increase of the sun's elevation results in the light bouncing off surfaces at a decreasingly acute angle, enabling newly formed colours to be viewed in all their glory. The growth of Nature's new cloak is illuminated and encouraged by the increased intensity of the light source, the sun, and we are able to appreciate fully the emerging hues.

The painting *Spring Shadows* was done in an area which has provided inspiration for many of my paintings. The long rectangular space is flanked by terraces of red brick Georgian houses (now offices) and rendered and colonnaded Regency buildings interspersed with new red brick buildings. The orientation and architectural detail combine to provide a profusion of lighting effects. The midday and still fairly low early spring sun beaming along the length of Southernhay casts intricate shadows on the grass. The clear light ricochets off the lawns and crocus rings to provide a strong tonal contrast with the trees and seated figures. Warm brick-reds complement greens while blue-violets jostle with yellows.

Spring Sentinels encapsulates most of the senses one associates with early spring. The light of a crystal-clear day releases the scent of daffodils and fresh grass.

RIGHT **Spring Shadows, Southernhay, Exeter.**
12¾ x 17 in (32.5 x 43.5cm). Chrome-green light Rembrandt board.

BELOW **Spring Sentinels.**
9¾ x 12¾ in (25 x 32.5cm).

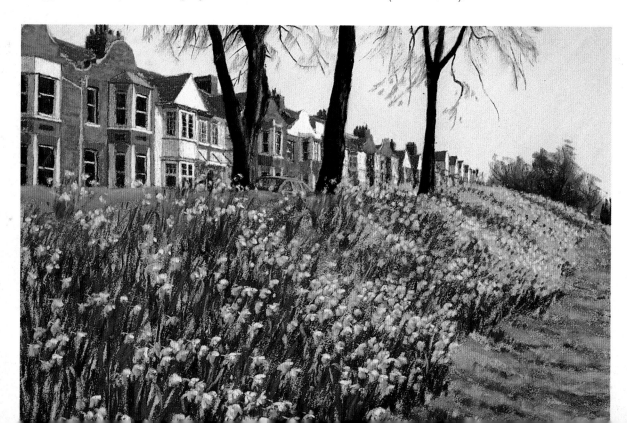

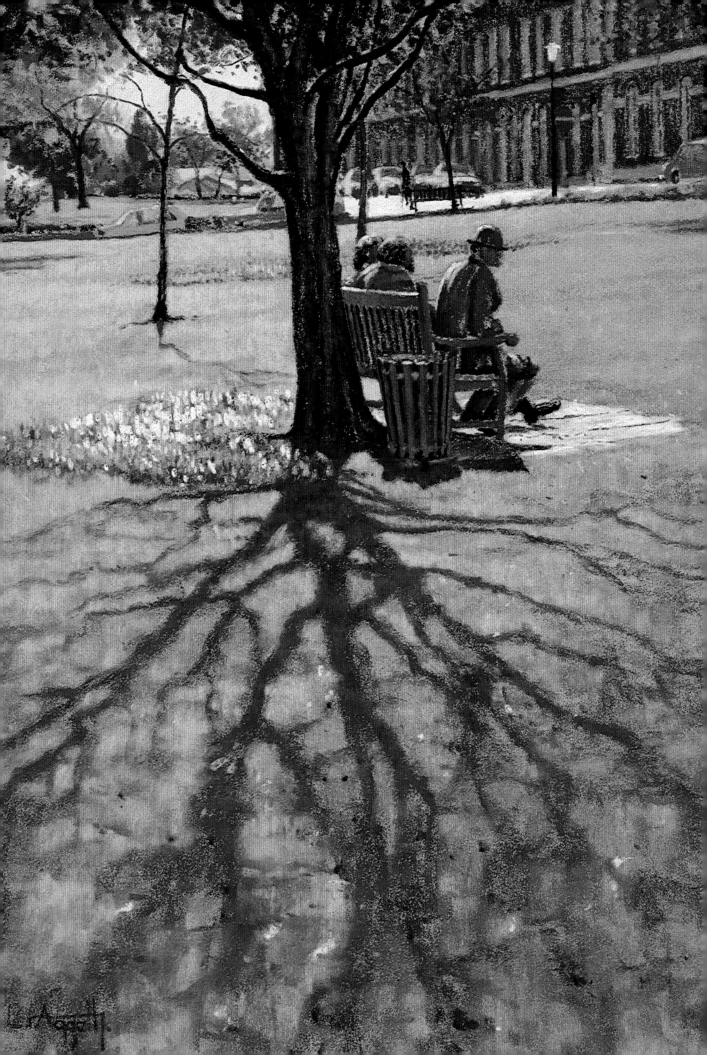

SUMMER

The sun is high and the light intense. The greater the radiance according to regional variation the more vivid and dramatic the colours will appear. Such conditions are represented by high-key paintings where predominantly saturated (pure) colours are deployed. (Influences controlling the extent to which hues are saturated are discussed in later sections.) Combinations of bright complementaries will enhance the effect of vibrant light in our paintings, and the heat suggested through the use of warm colours will be emphasized by contrasting cool shade colours.

In the painting *High Summer*, the dappled sunlight falling across the empty seat signifies the end of a hot midday break. The office workers have returned to their offices as the sun begins to bleach out the more brilliant hues that existed an hour or so earlier. The yellow-green sun highlights in the tree contrast with the glowing red of the buildings. The Georgian fenestration reflecting warm colours contrasts in turn with the deep rich hue of the brickwork.

By contrast, the Provençal countryside exhibits sunflowers almost as far as the eye can see, interspersed with small vineyards. What better symbol of summer heat than this noble flower, grown here as a crop for its oil. Executed on a full size sheet of Canson Mi-Teintes 340 (reverse side), the painting strives to capture the bleaching effect of the early afternoon sun. The blue-greens and blue-violets of the sky are reflected in the distant landscape providing subtle violet-yellow contrasts. The light in the Exe Valley is less intense. The warm late afternoon sun produces a patchwork of complementary hues from ploughed and rich green fields, somewhat tempered by the hint of a haze caused by the slight humidity. The distant hills and the landscape generally reflect the colour of the sky. The warm light defines the near foreground trees, contrasting with the shaded middle distance.

BELOW **High Summer, Southernhay East, Exeter.** 15¾ x 19½ in (40 x 50cm). *Collection of Mr and Mrs M Gibbs*

TOP RIGHT **Sunflowers below Bonnieux, Provence.** 21¾ x 29½ in (55 x 75cm). *Private collection*

RIGHT **The Exe Valley.** 19½ x 25½ in (50 x 65cm). Chrome-green light Rembrandt board. *Private collection*

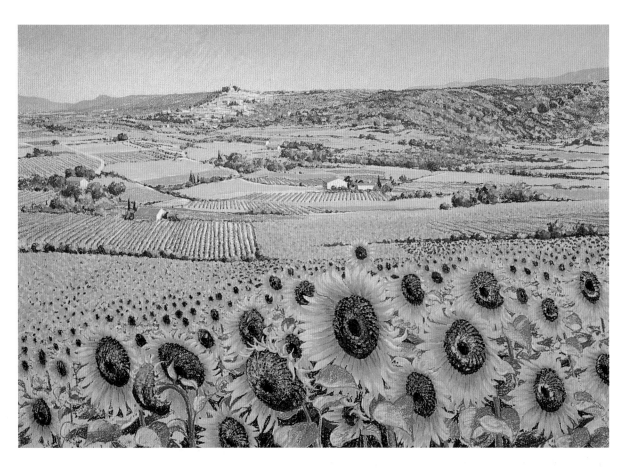

AUTUMN

The autumn light, generally cool and emitted from a lowering sun, reflects the warm colours of the leaves to provide areas contrasting in temperature. In summer the foliage absorbed the red and most of the blue from the spectrum and reflected green. In the autumn the production of chlorophyll is halted and the carotene pigments beneath are revealed to absorb greens and blues but reflect the rich golden yellows. Changes in temperature and humidity influence the play of light to produce ethereal effects charged with atmosphere.

In the first picture, light falling obliquely across grass filled with morning dew and illuminating the tree resplendent in autumn colours provides a subject of contrasting cool and warm colours. The contrast between the pointillist strokes regis-

tering the foliage and the flat strokes used to paint the rich shaded brickwork heightens the interest. Note the tonal contrast too. In the other, a shaft of morning light accentuates the area of interest at the base of the tree, throwing part of the empty seating into silhouette. The sun-filled foliage also contrasts with the shaded trees and buildings. Fallen leaves and the perspective of successive foreshortened bands of subdued light in the foreground lead up to the subject. Warm autumn hues contrast with cool blue-greens whilst green, red, yellow-orange and blue colours form complementary combinations.

BELOW **Autumn Gold, Southernhay East, Exeter.** 15¾ x 19½ in (40 x 50cm). *Private collection*

RIGHT **The Southernhay Plane, Exeter.** 12¾ x 9¾ in (32.5 x 25cm). Grey Rembrandt board.

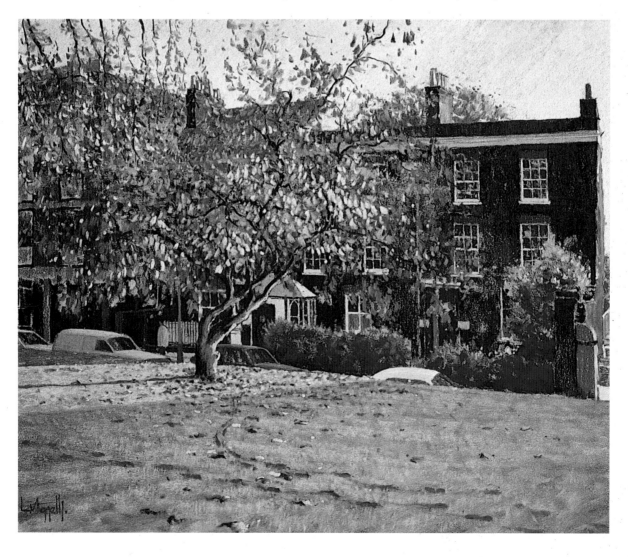

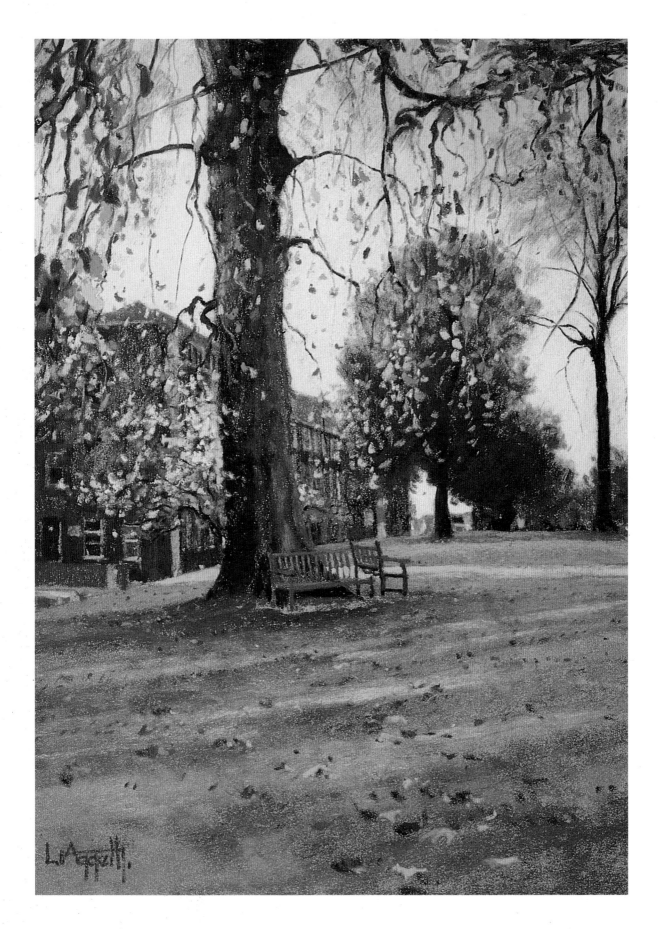

WINTER

Snow and its capacity for reflecting light fascinates me, and I make no apology for only including examples that portray the extreme visual experience of this apparently longest of the four seasons. Like most 'white' surfaces where virtually all the colours of the spectrum are reflected, therefore releasing no principal hue, snow reflects subtle colours 'borrowed' from other sources. For this reason it is never white. The sky provides most of the colour, supplemented by local influences such as buildings.

Whereas evergreen foliage remains to reflect deep greens, much rich warm colour is produced by the bare skeletal framework of trees and other vegetation. Buildings play an even greater part, revealing façades that are concealed by foliage during the other part of the year. The light is emitted and reflected at a low angle and therefore, although weaker in intensity, appears to be sometimes quite harsh, particularly when surfaces are wet.

In *Winter's Warmth* the cool colours of the sky contrast with the warm hues of the west front and towers of Exeter cathedral. The homogeneous effect of the snow accentuates the deep red brick and red Exeter stone façades of the Close. The sun lowering in the sky projects warm light and casts cool shadows across the snow. One red-green statement (girl in foreground) is placed in a general arrangement of quiet orange-blue complementaries.

In *Winter's Playground,* areas of the painting not directly lit by the rays of the warm sun reflect the steely gunmetal blue of the sky. The result is a range of subtle and faint orange-blue complementaries forming a homogeneous backdrop to the wonderfully rich warm colours of the stripped trees. Sleigh and ski marks together with the ascending scale of figures enhance the perspective. The choice of caput mortem red Rembrandt board provided a good ground for the painting.

BELOW **Winter's Warmth.**
15¾ x 19½ in (40 x 50cm).

BOTTOM RIGHT **Winter's Playground.**
12¾ x 17 in (32.5 x 43.5cm).

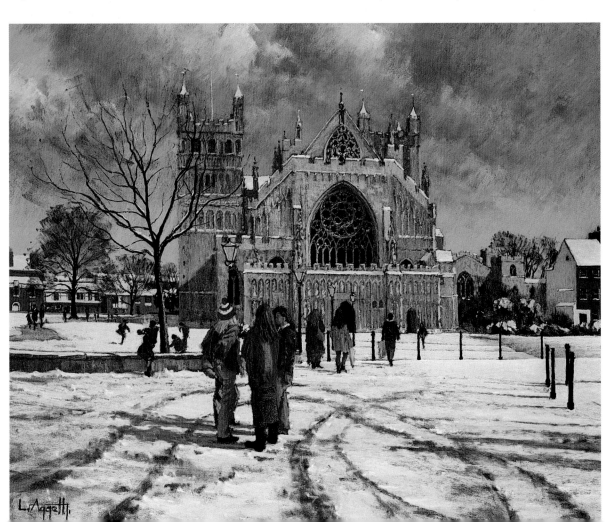

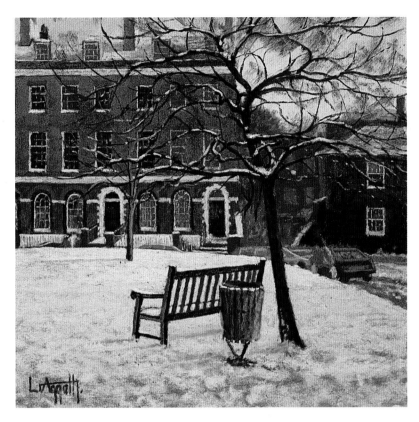

LEFT **Winter's Cloak, Southernhay, Exeter.**
6 x 6in (15 x 15cm).
Caput mortem red Rembrandt
board.
Collection of Mr and Mrs J Hunter
The small study of Southernhay under
snow encapsulates the observations
made concerning winter. The tree
stripped bare reveals the fine Georgian
red brick façade. The warm midday
sun casts shadows which reflect the cool
colours of the sky. Strong tonal con-
trast is provided by the empty seat, the
tree and sunlit area of snow.

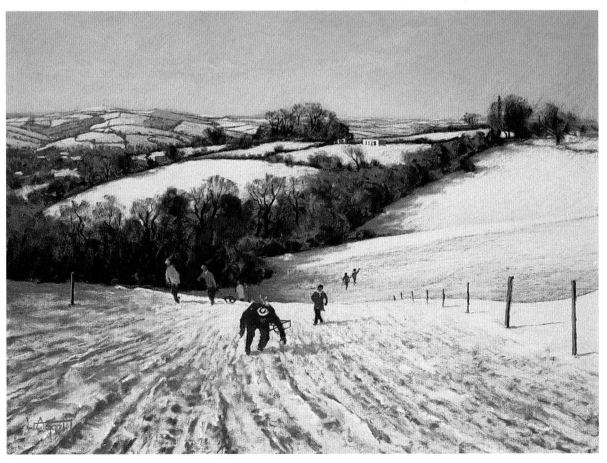

..

WEATHER CONDITIONS

..

There are other influences which will affect the quality of light whatever the time of day or season. The colours of the spectrum emitted from the sun are often at their most pure following a period of rain, when the skies clear and visibility appears to be perfect. The atmosphere has been cleared and there is nothing to obstruct the light. The colours reflected (rejected) by objects are as pure as they can be. In this situation one would use a high percentage of saturated colours in the painting. This does not often occur, however, particularly in a maritime climate, and even under a clear sky there is usually some atmospheric influence present.

Cloud cover is the most obvious and common obstruction to the passage of light. The light received by the landscape under a blanket of cloud – and therefore the colours rejected by it – are reduced in intensity to the extent that unsaturated colours are used to portray them.

There is no doubt that clear unrestrained light produces vibrant colour combinations that excite the brain, leading, we hope, to bright lively sun-filled paintings. Adverse weather conditions can, however, produce the stimulation and inspiration for works possessing much atmosphere and character where the need to capture the moment is paramount. We usually associate weather conditions with a particular locale and vice versa, as the following two paintings illustrate.

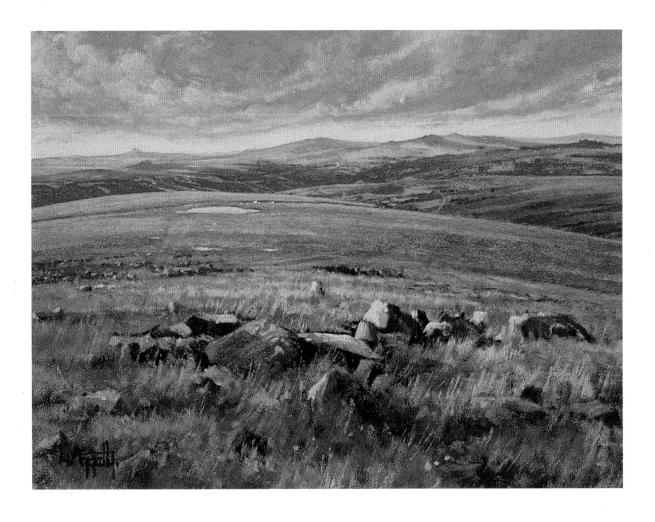

ABOVE **Dartmoor Light.**
9¾ x 12¾ in (25 x 32.5cm). Grey Rembrandt board.
Private collection

LEFT **Barolo, Piedmont.**
19½ x 25½ in (50 x 65cm). Yellow ochre Rembrandt board.

In the village of Barolo, in the Langhe district of Piedmont, the scenery is as good as the wine. The vineyards are gathered around the village which nestles in a hollow, unlike its neighbours which perch on hilltops. There is usually a haze even on a clear day, as captured in the painting. The light is also 'softer' here in the hills than across on the coast. The haze, and the vineyards taking on some of the sky colour, provide picto-rial perspective, augmented by the rows of vines.

Whereas the Barolo painting typifies the light and character of the Langhe region, I feel the study *Dartmoor Light* personifies the light and character of Dartmoor, another of my favourite haunts. Dartmoor is extremely pleasant under a blue sky with skylarks singing, but the true rugged qualities of the moor are only revealed under the sort of conditions depicted here. The grey and ochre sky, with a small pair of 'sailor's pants' (blue sky) top right, is reflected in the landscape. To give subtle contrast there is a hint of filtered light in the foreground and middle distance due to small gaps in the cloud. The light at Barolo was referred to as soft, being away from the Mediterranean coast, but here it is much softer.

TYPES OF CLOUD COVER

Cloud affects the quality of light to varying degrees according to the type and formation of cover. Obviously the more dense and larger the cover the greater the reduction in the amount of clear light there will be. Sometimes the influence will be very little but whether there is a large or small amount of cloud the sky – the provider of light from the source, the sun – should never be ignored. The skyscape can be as important as the landscape in a painting, and may sometimes be considered the dominant feature. It is important therefore that we should study, observe and record cloud effects as often as we can. They are tied inexorably to the lighting

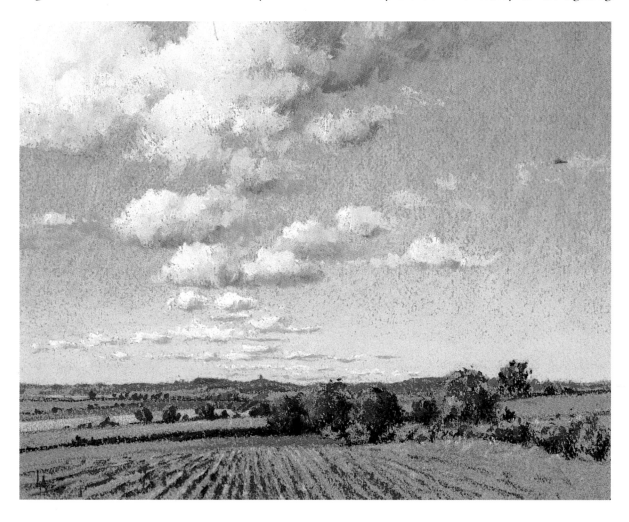

ABOVE **Cumulus.**
9 x 11 in (23 x 29cm).
Almost cauliflower-like cumulus clouds appear over the well-known landmark of Haldon Belvedere in the Haldon Hills that overlook Exeter. The clouds are of the heap type with a shaded flat base and rounded light top. These sometimes move fairly swiftly, casting shadows over the landscape and providing areas of contrasting light and shade.

conditions and the effect they have on the colour and tonal changes in the landscape.

There are two basic types of cloud. Layer cloud is formed when a large mass of air rises to form sheets or layers of cloud. Called stratus, these are usually associated with stable weather and are responsible for those uniformly leaden skies and persistent rain which are a feature of Britain's maritime climate.

The other main type is referred to as heap clouds, or cumulus. Unlike layer clouds these do not cover the sky completely. Formed when pockets of air rise quickly, they climb and develop vertically, sometimes to great heights. This cloud is very often associated with showers on hot summery days when cold air is heated from below.

Most of the following examples have been painted on Canson Mi-Teintes 431 grey paper using the range of grey pastels. The influence cloud cover has on the quality of light is therefore expressed in tonal form.

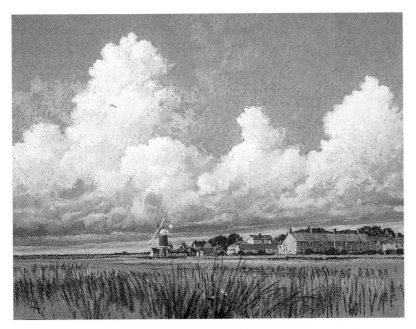

LEFT **Cumulus Congestus.**
9 x 11 in (23 x 29cm).
The huge skies of Norfolk are often filled with cumulus congestus which is formed when cumulus clouds develop vertically to the extent where their height dramatically exceeds the width of their base. In this view of Cley the flat, unbroken dark base extends across the horizon echoing the flat landscape and contrasting with the white sails of the mill, lit from the sky above the towering, rising cloud.

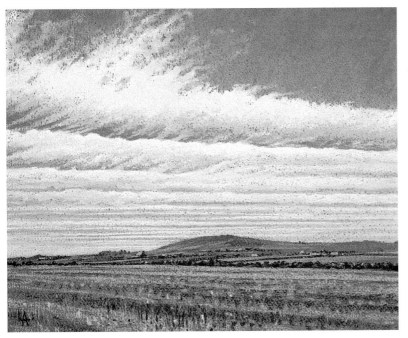

LEFT **Stratocumulus.**
9 x 11 in (23 x 29cm).
Stratocumulus, a layer type, is sometimes formed when the vertical growth of the cumulus cloud is halted by changes in the stability of the atmosphere. The one-time cumulus spreads out and flattens into rolls or as indicated here forms undulating layers. The cloud form follows the general landscape and lines of stubble and accentuates the last hill of the peninsula at Crows-an-Wra, Cornwall. The light emerging through the cloud is filtered according to the varying thickness of the layer.

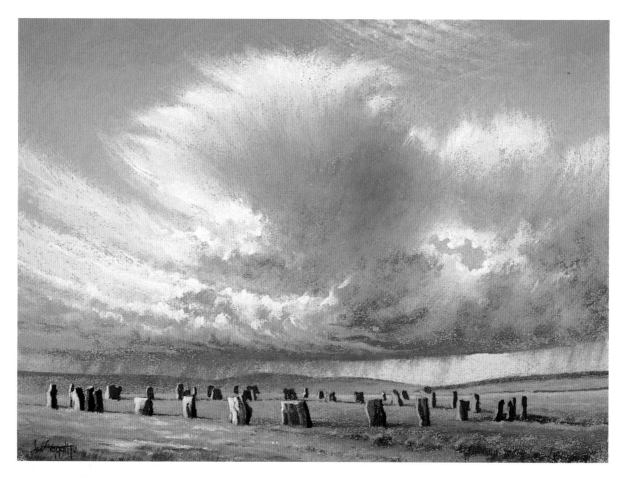

ABOVE **Cumulonimbus.**
12¾ x 17 in (32.5m x 43.5cm).
Capable of producing tremendous storms, cumulonimbus are spectacular clouds which can develop to heights of 12,000m (40,000ft). Their chief characteristic is the fibrous top referred to as the anvil. This occurs when the top reaches the upper atmosphere and becomes icy. These ice crystals are swept aside by the high-level wind to form the distinctive 'anvil' head.

One of the most dramatic optical phenomena, the cumulonimbus cloud will produce a dramatic effect on the ground. Here the huge cloud rising behind Grey Wethers twin circles on Dartmoor sheds rain from its dark base. Some of the stones are silhouetted against sunlit areas whilst others, catching sunlight, contrast with the rain and shaded hills. The warm and cool greys of the cloud are reflected in the distant hills and shaded areas. I used Canson Mi-Teintes 354, blue-grey paper, reverse face.

TOP RIGHT **Stratus Fractus.**
9 x 11 in (23 x 29cm).
Stratus fractus are usually associated with hill fog or grey water clouds forming a uniform layer. The stratus is the lowest cloud in the sky and is known as fog if covering hills or coasts. Fractus is a term applied only to cumulus and stratus clouds and refers to the irregular edges which are convoluted in appearance. This view of Crowcombe Park on the Quantocks looking towards Minehead shows the ragged edge of the stratus fractus covering Hurley Beacon. The well filtered light pulls the tonal extremes of the sketch fairly close together.

BOTTOM RIGHT **Nimbostratus.**
9 x 11½ in (23 x 29cm).
Nimbostratus are dull grey, low-level clouds without any form to them. They are always accompanied by rain or snow and sometimes the light filtering through them is reduced to such an extent that daytime looks almost like late evening. The rain and cloud reduces the form in the landscape thus requiring a low-key rendering to capture the atmosphere and mood. Nimbostratus clouds turn daytime to evening in this view of a narrowboat approaching a lock on the South Oxford Canal, where stillness and tranquillity are heightened by mood.

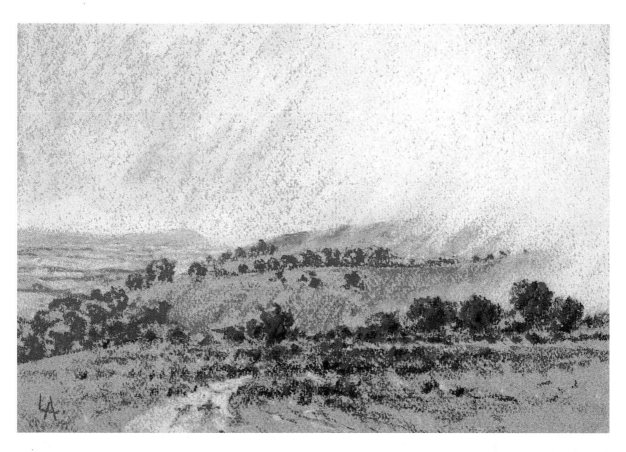

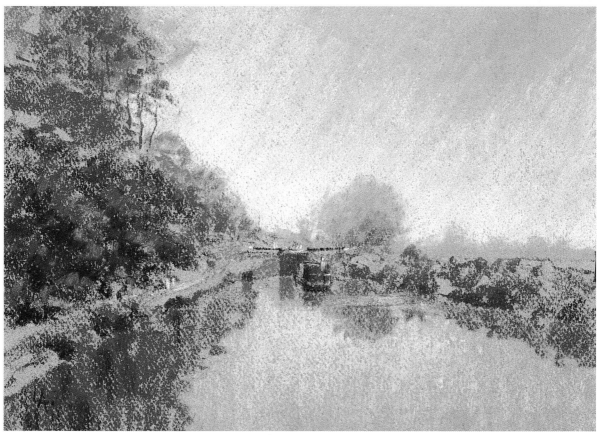

BELOW **Altostratus.**
12¾ x 17 in (32.5 x 43.5cm).
Altostratus are layer clouds which often portend rain. They are sometimes thin enough to allow the sun to penetrate in a diffused manner to create subtle atmospheric effects of light and colour ('watery sunlight'). These are at their most striking either early or late in the day. I used Canson Mi-

Teintes 354, blue-grey paper (reverse face) for this view on top of the Quantock Hills in Somerset to capture the altostratus of early morning. The sun, still low in the sky, struggles to pierce the cloud layer, producing a milky effect. The light emitted has an opal quality and the resultant ochre/yellow-gold hue pervades the whole landscape, being almost mirrored

in the path and dry grasses. The brown, blue and purple-greys are echoed in the distant hills and near heather, to form a low-key complementary combination. Altocumulus clouds, a mixture of ice and supercooled water, climb up into the sky, whilst the darker nimbostratus forming the base of the 'superstructure', straddles the horizon.

TOP RIGHT **Altocumulus Lenticularis.**
9 x 11½ in (23 x 29cm).
As air approaches a hilly or mountainous area it is forced to rise and pass over it. Clouds are then formed. The higher the peak the more likely it is that the top will be almost permanently shrouded. Such altocumulus lenticularis clouds are not only confined to hilly peaks, however, and can be seen as medium-level heap clouds sometimes isolated and usually not covering the whole sky. Clouds of this type assume

a lens-like shape, hence the name lenticular.
This example over White Hill and Cawsand Beacon on the edge of Dartmoor behind Whiddon Down has taken on the form of a 'whale' flanked by smaller lens-shaped clouds. The shaded 'body' with an almost halo-lit periphery makes them appear quite luminous.

BOTTOM RIGHT **Altocumulus.**
9 x 11½ in (23 x 29cm).
Commonly referred to as a 'mackerel

sky', altocumulus cloud is made up of a large dappled area of flattened globules. These are mixtures of ice and supercooled water. They can sometimes mark the end of a long spell of hot weather, to be followed by thunderstorms. Altocumulus cloud is often dramatic and here, above St Just in Penwith, Cornwall, the form relates to the landscape and accentuates the prominent position of the church tower. This is an example where the sky is as important as the land in the overall composition.

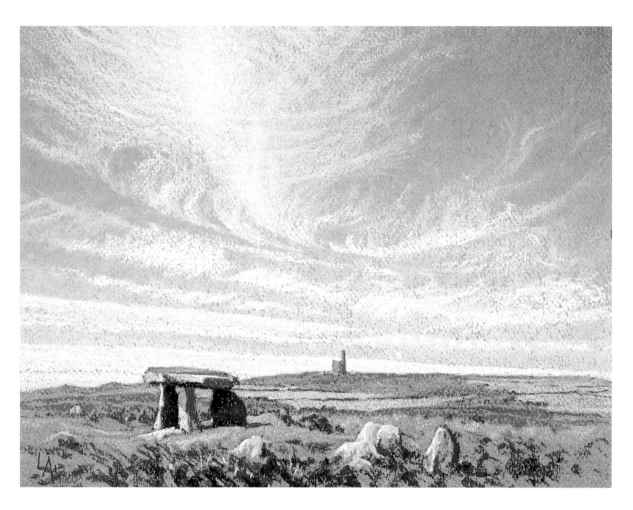

ABOVE **Cirrus.**
9 x 11½ in (23 x 29cm).
Cirrus are high-level clouds, found at around 6,000m (20,000ft). They are formed of ice crystals and are recognizable for their feathery wispy appearance, often termed 'mares tails'. The clouds again form an important part of the composition in this study. Cornwall, where I painted this picture, is fairly flat, rather like a plateau with deep valley rivulets above which very large skies can be seen to play a prominent role in accentuating the mood and character of the landscape.

TOP RIGHT **Cirrostratus.**
9 x 11½ in (23 x 29cm).
Also to be seen at high level, cirrostratus are amorphous clouds formed of tiny ice crystals. Covering much of the sky in a layer, they can often be a sign of bad weather. The halo effect which sometimes occurs around the sun or moon through refraction of the light source's rays is well known as an indicator of impending rain.

The sun pillar viewed over the marshes at Stiffkey in Norfolk is a phenomenon associated with cirrostratus clouds. The sun's rays are refracted upwards to form a head of faintly luminous light, and reflected downwards across the marshes between the reeds. The sense of vast open space and distance is heightened through the multi-layered perspective both above and below the horizon.

RIGHT **Cirrocumulus.**
9 x 11½ in (23 x 29cm).
Cirrocumulus are high ice clouds, a heaped form of cirrus, which form regular dappled and rippled patterns similar to, but more refined than the 'mackerel' sky associated with altocumulus clouds.

The interest in this fishing scene on the Norfolk coast at Saltmarsh pivots between the tonal contrast of the two dark umbrellas and the luminous sky. The strong foreground balances the enormous rippled sky which looks like a sandy beach when the tide is out.

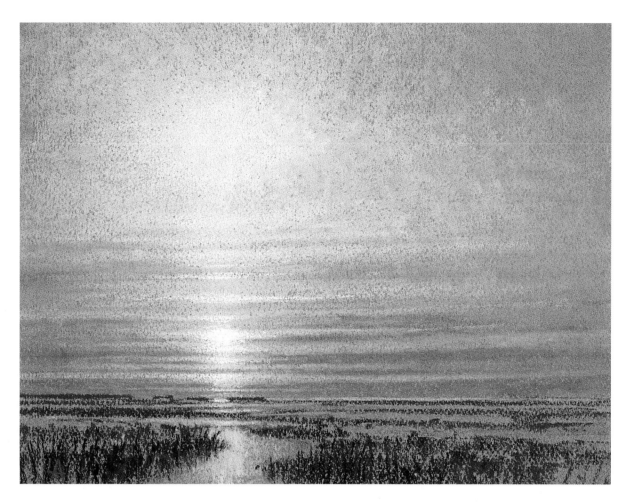

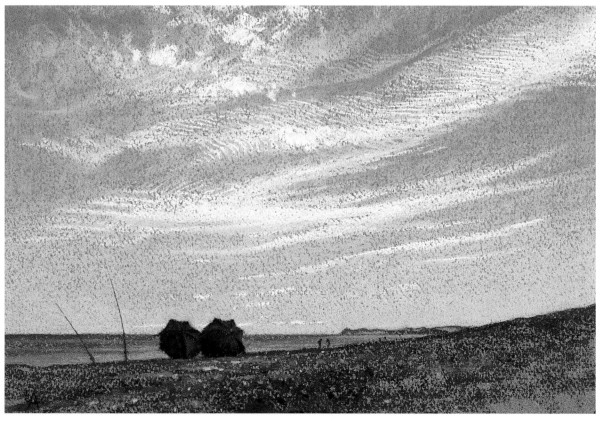

ATMOSPHERIC EFFECTS

The passage of light may be impaired even during the absence of heavy cloud and rain. Atmospheric effects can be brought about by changes in humidity and condensation. When these phenomena combine with any form of pollution the situation is exacerbated. The effects created by light trying to pierce these conditions can, however, be quite spectacular. Monet's romance with steam in his paintings of the Gare Saint-Lazare, and his atmospheric paintings of the Seine and tributaries at Vétheuil and around Giverny bear testimony to that. His struggle with the series of paintings capturing the changing light made visible in the smoke, mist and fog of the poisonous London atmosphere do even more so, perhaps.

BELOW **Devon Fields.**
9¾ x 12¾ in (25 x 32.5cm). Green light Rembrandt board.

HEAT HAZE

Heat haze is formed by rapid evaporation during the summer heat which produces a hazy atmosphere. Sky and the landscape merge with a blue-violet and blue-green semi-turbidity which permeates the scene. The intensity of the filtered light increases somewhat towards the nearer sections and releases brighter colours in the foreground. In the painting *Devon Fields*, the higher intensity of the foreground light illuminates the farm with a soft, warm glow.

MORNING MIST

Mist forms when the moisture in the air is cooled until it reaches its dew point. At this point the air is unable to retain all the moisture in the form of water vapour and condenses.

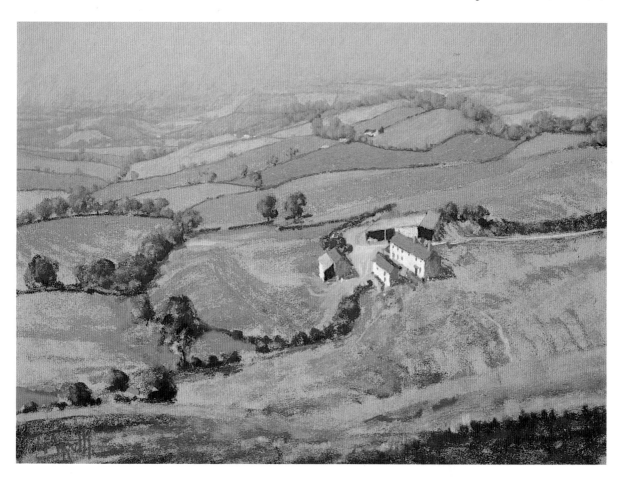

Mist and fog are part of the same process and the essential difference is that we refer to the phenomenon as fog when visibility is less than 200m (650ft). When we can see further than this distance it is known as mist. Mist seldom obscures the sun, and provided there are no clouds to conceal the light source the condition produces a variety of delicate effects.

The scene *Morning Mist* was executed using the range of greys on Mi-Teintes 431 grey paper, and portrays the stillness of fragile moving light where the only other oscillation is the thickening and thinning of the mist across the sun, bringing subtle changes to the faint luminosity. Forms and shadows almost become as one in the haze of opalescent light. The barely distinguishable shapes merge with the light echoed in the reflections. I recall observing such conditions during my schooldays when during holidays I went on early morning bream-fishing expeditions armed with sketch book and, of course, fishing rod!

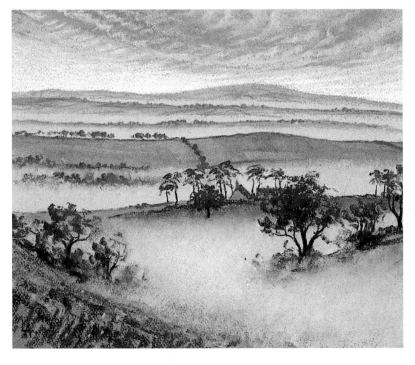

FOG

Fog often occurs in small valleys and hollows. This is caused by the air at the side of the valleys cooling at night and pouring down like a liquid, then cooling at the bottom where the condensation forms.

The visibility in the hollows will be less than 200m (650ft), providing a thick blanket which when viewed from above looks like cotton wool. The effect is quite spectacular, as recorded in the sketch *Chapel Downs*, again using the same materials as in *Morning Mist*, produced just across from my studio. The light is reflected by the fog so what we see is an almost white shroud masking all detail with the exception of the land mass rising above it. At this level the air is clear and the light is absorbed to provide a quite striking tonal contrast.

TOP LEFT **Morning Mist.**
9¾ x 12¾ in (25 x 32.5cm).

LEFT **Chapel Downs, Crediton.**
9¾ x 12¾ in (25 x 32.5cm).

SMOKE POLLUTION

Air pollution is thankfully diminishing as a visual source of inspiration for artists, for we are gradually cleaning up our act. We still have a long way to go, however, in respect of largely unseen chemical pollution, the presence of which is only apparent when we are confronted with the results, such as fish killed by chemical spillage into the river system. We are warned that the 'greenhouse' effect will change our landscape unless efforts are made to reduce and ultimately halt the amount of noxious gases being released into the atmosphere. If we fail to arrest the amount of ultraviolet then the palette chosen for Provence might well eventually suit Dartmoor! Despite the dangers, factories still emit chemicals and steam, particularly in Eastern Europe. There are localized examples of smoke pollution too.

No longer practised in Britain, the burning of stubble used to present a seasonal pastoral scene for the painter. Painted on grey Rembrandt board this almost identical view (below) to the painting entitled *Devon Fields* on page 50 is an example of the practice. Here the

RIGHT **Vine Trimming, Saint-Amour, Beaujolais.**
9¾ x 12¾ in (25 x 32.5cm).

BELOW **Swaling, Mid-Devon.**
9¾ x 12¾ in (25 x 32.5cm).

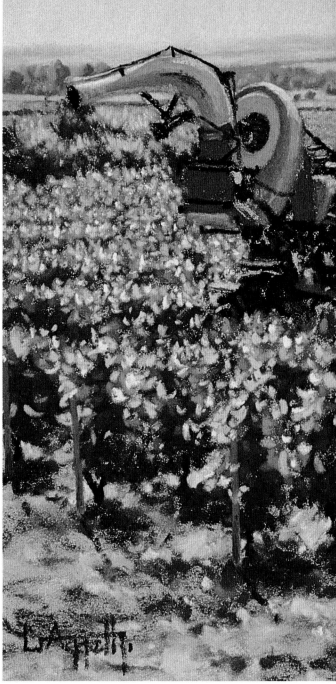

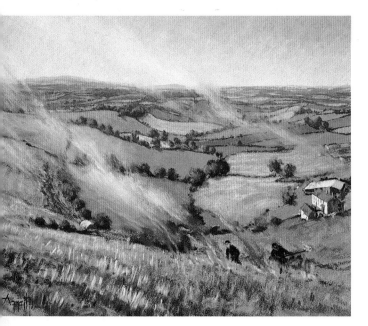

visibility is reasonably clear apart from the smoke particles which obscure vision and both filter and reflect light. The smoke casts moving shadows over the stubble and the light generally is filtered with thinned and diffused smoke. The feeling of heat is quite strong, accentuated by the warm colours of the fields, foreground stubble, earth and the flames. The smoke reflects these colours, contrasted by cool touches within the plumes.

DUST

Another form of localized pollution (although sandstorms can whip sand and dust high in the atmosphere to be transported hundred of miles),

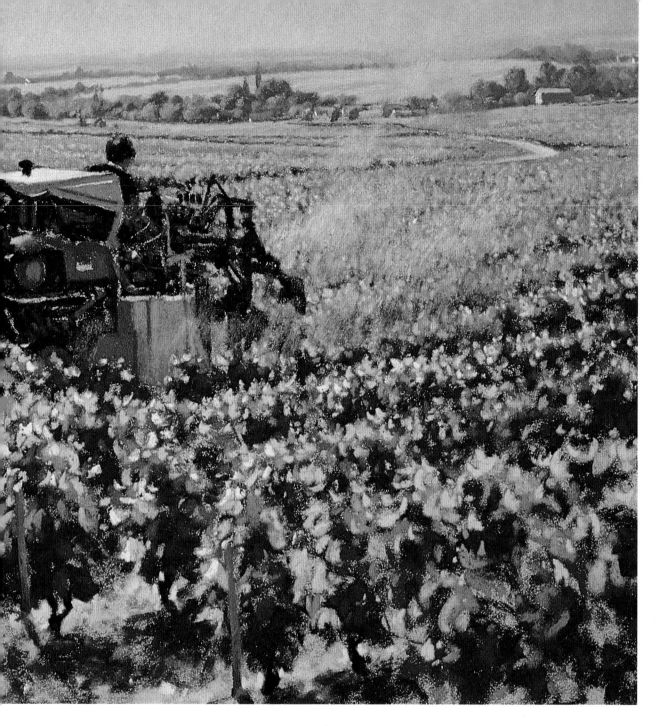

dust produces semi-cloud effects thus influencing light. Volcanic eruptions are another dust source.

On a smaller scale, quarrying, building demolition and excavation are forms of pollution. Smaller still, the activities of milling, harvesting, haymaking and even ploughing create dust. All the time conscious efforts are being made to reduce the amount of dust released into the atmosphere for safety both globally and in the workplace. As with any pollution, the effect is to filter light to varying degrees.

The varied seasonal light around the hills of the Beaujolais villages has provided inspiration for many of my paintings. The mist and haze at harvest time is perhaps my favourite season, not least

because the whole area is bathed in the aroma of the vendange. I used raw sienna Rembrandt board for this study (above) at Saint-Amour, one of the nine crus villages, on the edge of the area. The scene shows the spring task of trimming the young vines by machine following the process of bunching by hand.

The dry soil is disturbed by the wheels which send clouds of dust into the air to be despatched by the gentle breeze. More light is absorbed compared with smoke and a slight shadow is cast over the vines. The area of movement and partial concealment caused by the dust contrasts with the clear visibility and vibrant bouncing light and colour reflected by the trimmer and the vines.

ABSORPTION AND DEFLECTION OF LIGHT

All subjects absorb some parts of the light spectrum and reject those which we see as colour. The colour we see depends on the chemical structure of the surface. The more light absorbed the darker the colour released, and the less light absorbed the lighter (in general terms) is the colour reflected. The visual senses are often heightened when this phenomenon is combined with certain textures.

If light strikes a hard smooth surface which has a chemical composition that rejects most or all of the colours of light, the pale colour that we receive is enhanced. This applies even more so if the surface is smooth or even shiny, whereby its deflective properties are increased, eg white marble. Similarly, if a soft and heavily textured surface possesses a chemical structure that absorbs most of the colours of light, then the dark colour we receive is also enhanced, eg dark, tilled earth.

When brought together, these and other comparisons produce subjects that will exercise the viewer's senses. Anyone who has seen the spectacular white marble quarries glistening in the hills around Carrara in north-western Italy will appreciate that here is an example of textural differences, enhanced by the absorption and deflection of light.

The colours of any landscape are controlled by absorption and deflection. Most of the colour we see is reflected from objects (rejected colour) and the rest is deflected by objects. A good example of deflection is overturned grass or a smooth leaf. These will deflect the colour of the sky. Multiply this several million times over and a green field will taken on a bluish tinge, or whatever colour pervades the sky. I have referred to this aspect of landscape painting before, and will do so again before we are through.

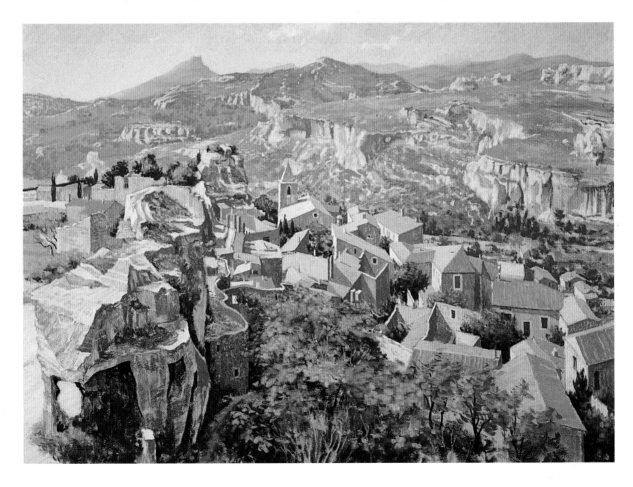

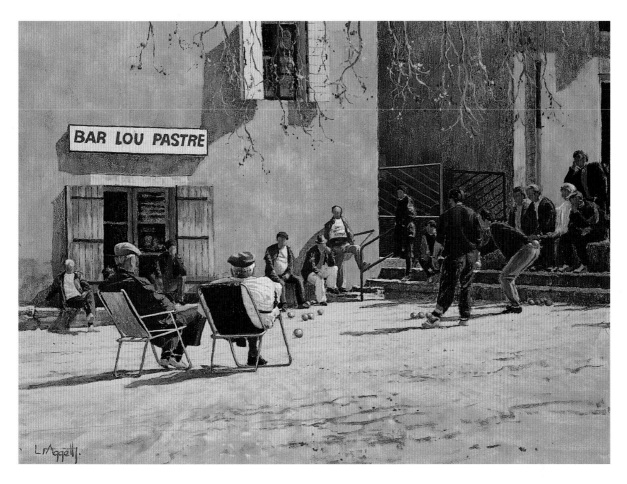

LEFT **Les Baux de Provence.**
19½ x 25½ in (50 x 65cm).
Raw sienna Rembrandt board.
Private collection
*Best seen during late evening, by
moonlight or out of season, for this is
probably the best known and most fre-
quently visited of Provence's villages
perchés: Les Baux is a truly breath-
taking place. This applies particularly
when viewed from the old ramparts.
The name is derived from the
Provençal word for rock, 'baou'. The
view of the ruins of the old fortress
from the vineyards and olive groves
below is equally impressive.*

*The painting, from the higher
deserted village and fortress overlooking
the 'living village' of Les Baux de
Provence, provides an example of the
contrasts produced by the interaction of
deflected and absorbed light. The bril-
liance, angularity and hardness of the
carved rocks and constructed buildings
deflect light as well as reflecting a small*

*amount of colour. The colour of the
sky is also deflected by these surfaces.
It is a common belief that all Provence
is a blaze of bright rich vibrant hues
best represented by daubs of saturated
colour. In truth, however, the relent-
less sun has bleached everything that is
permanent, including roof tiles, to such
an extent that the amount of coloured
light absorbed is reduced, owing to the
chemical changes on the surfaces.
There are, of course, brilliant intense
passages of colour provided by vegeta-
tion according to the season. It would
have been tempting perhaps to enrich
the colour of the tiles to give extra
warmth. Mindful of our code of truth-
fulness, however, I can confirm that
the hues produced in the painting are a
more accurate record of the almost
'white heat' present.*

*The softer passages of the foreground
vegetation, where more coloured light
is absorbed, provide contrast to the
hard, bleached areas. The pictorial*

*perspective produced by the blue-violets
and blue-greens of the slightly hazy
hills in the distance, and the strong
tonal differences between light and
shade, combine to produce a vibrant
painting.*

ABOVE **Le Premier de la Saison.**
19½ x 25½ in (50 x 65cm).
Raw sienna Rembrandt board.
Private collection
*These men taking an extended lunch
break at Apt are, in true Provençal
style, engaged in a serious game of
boules, despite the chilly early March
conditions. The dark blue sweaters,
jackets and trousers almost merge with
the shadows on the right, whilst to left
of centre the deep red earth chair
absorbing almost all the coloured light
contrasts with the pale coloured harder,
gritty surface of the 'temporary' boules
court. The angle and position of the
two seated figures lead the eye to the
focal point of the action.*

Chapter 4
ARTIFICIAL LIGHT

Artificial light is capable of producing many moods and is used architecturally to create all manner of effects. It is a wonderful implement: in the hands of a good creative designer it can be used to woo and entice customers into commercial centres, to relax patrons in pubs and restaurants, and to excite and mesmerize audiences in pop concerts and the fantasy of theatre. Lighting is also used with increasing effect to enhance the character of our homes. We have come a long way from the 'central ceiling rose, bulb and shade'. The advancement of external lighting technology is evident in the continually improved illumination of roads, walkways and buildings. For the home we can buy a set of garden, pond, and patio lights which run on minute amounts of electricity. At a price, we can purchase 'everlasting' bulbs.

Both internally and externally, artificial lighting is used to create environments of every mood, and these provide stimulating subjects of great interest to the artist.

RIGHT **The Exchange, Crediton.**
12¾ x 9¾ in (32.5 x 25cm).
Lit by tungsten lights of various sorts (surface and recessed spot and wash lamps, with red filtered lamps off to the left), the brown and red colour theme is heightened because there is very little blue and violet light to be reflected. The main colours used for the painting were red earths, reds and yellow-golds. Caput mortem red Rembrandt board was used for the support.

OPPOSITE PAGE **The Burlington Arcade, London.**
12¾ x 9¾ in (32.5 x 25cm).
Private collection
Painted on grey Rembrandt board this study shows the effect of combined sources of light. The natural light diffused through the skylight dominates, but even during daytime the lighting from the shops spills out from both sides creating subtle effects at pedestrian level. In the foreground blue-violet light received from the fluorescent lamps in the shop can be seen reflected by the floor surface, as can tungsten lamps on the right which emit a warmer light. Warm/cool passages are produced throughout the painting using subtle yellow-violet and blue-orange combinations.

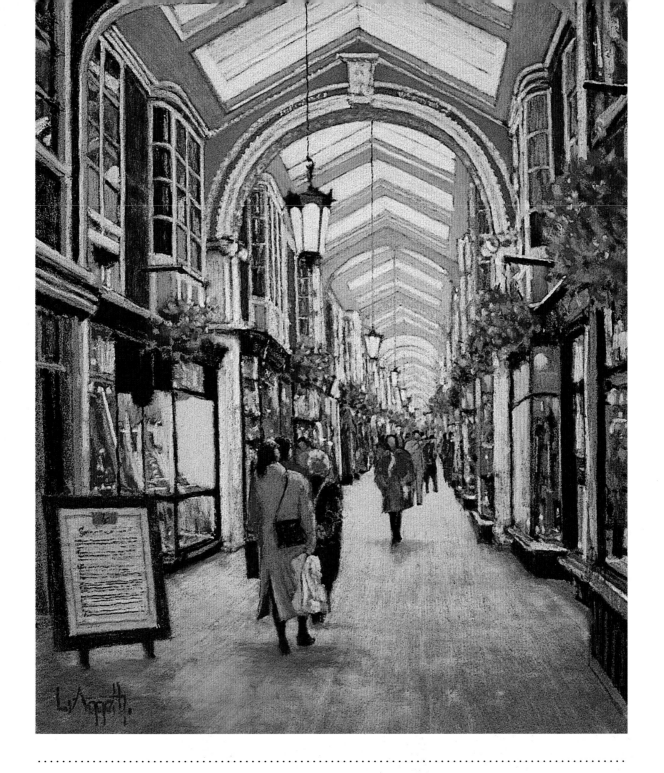

TYPES OF LAMP

The surface of the sun is extremely hot, burning away at approximately 6,500°C. The tungsten filament of a 100-watt bulb is heated to just under half that temperature. It follows therefore that the quality of light emitted from a tungsten filament bulb will be rather different from that produced by the natural source, the sun. The bulb emits only a small amount of blue and violet light compared with the sun, and therefore when these are rejected by an object there is very little of them to be seen as colour. In contrast to filament lights, fluorescent lamps with mercury vapour in their tubes produce light without generating heat. The light emitted has a higher percentage of blue and violet compared with the other colours. Each type of lamp therefore provides light of differing quality, and both are dissimilar to sunlight.

FILTERS AND SHADES

The quality of artificial light can be affected or influenced by placing coloured filters over the lamp or even by colouring the lamp itself. The light, colour filtered or otherwise, may be directed or shielded by the use of shades. Theatre lights and photo floods are directed by the use of sophisticated shades. 'Barn doors', flaps hinged to the sides, soffit and top of the lamp face, are painted matt black to absorb unwanted light and direct the beam to the focal point of illumination. If they were light-coloured or even white there would be a spillage of light through reflection and deflection.

Shades and filters can therefore be used to complement the décor of a room, as shown in

BELOW **The Carousel, Avignon, Provence.**
12¾ x 9¾ in (32.5 x 25cm).

The Exchange, or to change totally the character of a neutral scheme by switching emphasis through a choice of lamps and the use of dimmer controls. Their use is not, of course, confined to interiors as three of the four paintings show.

In *The Carousel* the globular lamps allow light to spill upwards, illuminating the underside of the foliage and intensifying the inky darkness of the sky beyond. The roof of the giant carousel, on the other hand, acts as a shade forcing the bright light outwards and across the square, embracing everything in its path.

The term 'pivotal' could be used to describe the positioning of the carousel in the painting. The perspective of the figures leading around both sides accentuates the rotundity, taking the senses behind, and then the eye beyond the foreground restaurant, down the square and back

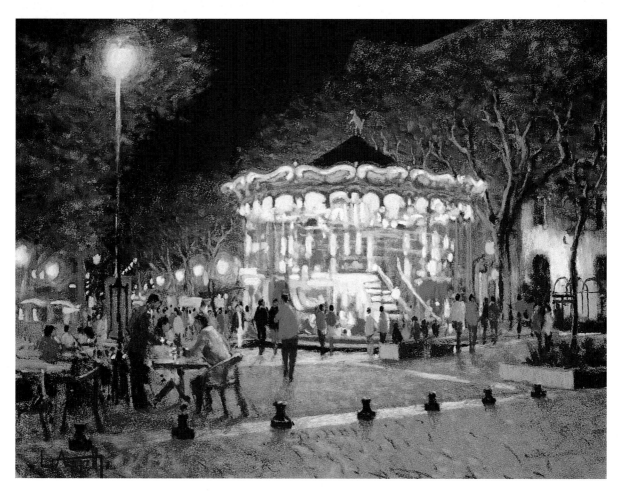

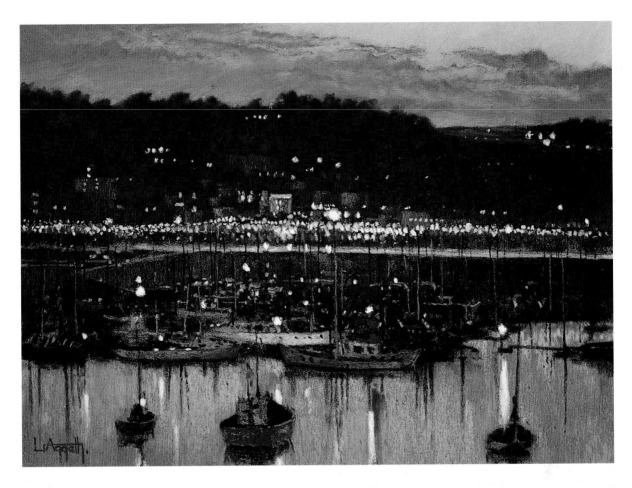

ABOVE **Torquay Lights.**
12¾ x 9¾ in (32.5 x 25cm).

through the void in the sky to the carousel. The mini bollards, strongly silhouetted, assist in this movement. There are many small compositions within the general movement of the painting, the fulcrum of which is the bottom left 'corner' of the merry-go-round.

I have deliberately used blue-violets in the silhouettes and shaded areas to complement the yellow of the direct light. There are also red-green combinations. I used permanent red deep Rembrandt board as the support.

The other painting shows the Devon Riviera in all its summer night-time glory. The remnants of the long-past sunset are still visible in the sky above Torquay harbour front, and therefore this painting cannot be regarded as a complete example of artificial light.

The myriad of man-made light sources providing this resonant son et lumière does, however, warrant inclusion at this juncture. The lighting composed of mercury vapour, halogen, neon, and tungsten in the form of streetlights, decorative colour-filtered lights, floodlights,

neon signs, hotel, commercial and dwelling (room) lights, boat lights and vehicle lights, produces a scintillation of flickering luminosity, contrasting with the dark curtain of the hills behind. Although most of the lights are still, movement is produced by vehicular lights, and flashing lights, pedestrians and vehicles passing in front of lights and also by the gently swaying masts of the boats in the harbour. To capture the tranquillity of the harbour scene with reflections backed by this teeming magnitude of glittering movement, posed quite a challenge. Flat strokes of earth reds, blue-violets, and yellow-golds laid the foundation on caput mortem red Rembrandt board for the final application of the lights with pointillist marks. Blue-orange, yellow-violet and red-green combinations provide a sense of 'movement', although the overriding use of the complementary device is the overall yellow accent placed against the blue-violet backdrop.

SPOTS AND WALL WASHERS

Improved lighting technology has led to what could be described as a new art form presented on the stage platform. Taken to (and sometimes perhaps beyond) the limits of visual acceptance, effects are used to heighten the drama and impact of musicians playing at pop concerts. Strobe and pulse units are linked to the sound system so that the beat controls the light output. The resulting effects add to the entertainment and are often spectacular, sometimes more so than the performers themselves! There is no doubt that a good band is enhanced by these aerial hieroglyphics, produced mostly with spotlights of one sort or another.

Spots are used as a means of highlighting areas of interest, eg clothes in shop windows and (externally) monuments. The origin of the phrase 'putting oneself in the spotlight' is obvious. Wall washers, on the other hand, are used to flood flat surfaces with fairly even light, sometimes producing a floating appearance. Often used externally and internally as an integral part of building design, they can highlight general areas, throwing forward forms into silhouette.

The use of a blue-violet Rembrandt board as a base for the lively subject of *Scintillating Rhythm* seemed to be a sensible choice. The dark passages were laid in first and I then gradually worked from this foundation, painting from dark to light. The intermingling shafts of coloured light required a lot of blending using pastel sticks alone, for the most part, applied with strokes of varying pressure, and the tip of my finger for some of the white light. Strong yellow-violet and blue-orange combinations add to the movement in both the performance and painting.

Blue-orange and yellow-violet combinations also dominate the painting *Quai André Citroën*, executed on grey Rembrandt board. The subject is a good example of a washed wall of light, where the source is concealed in a trough at the base of the wall. The smooth face of the stone reflects the light which throws the young Parisian descending the steps into a strongly defined silhouette.

This contemporary corner in the new development alongside the Seine on the South Bank

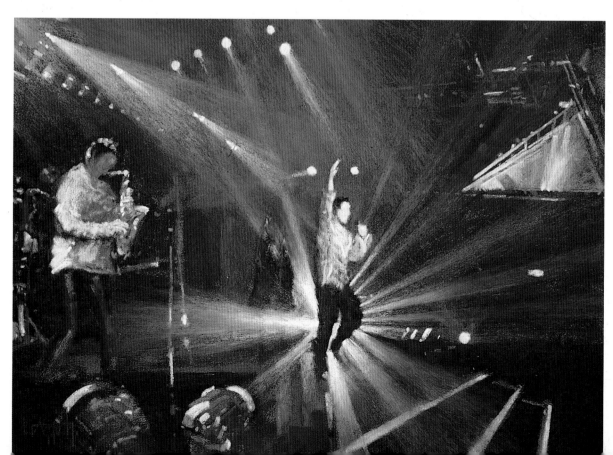

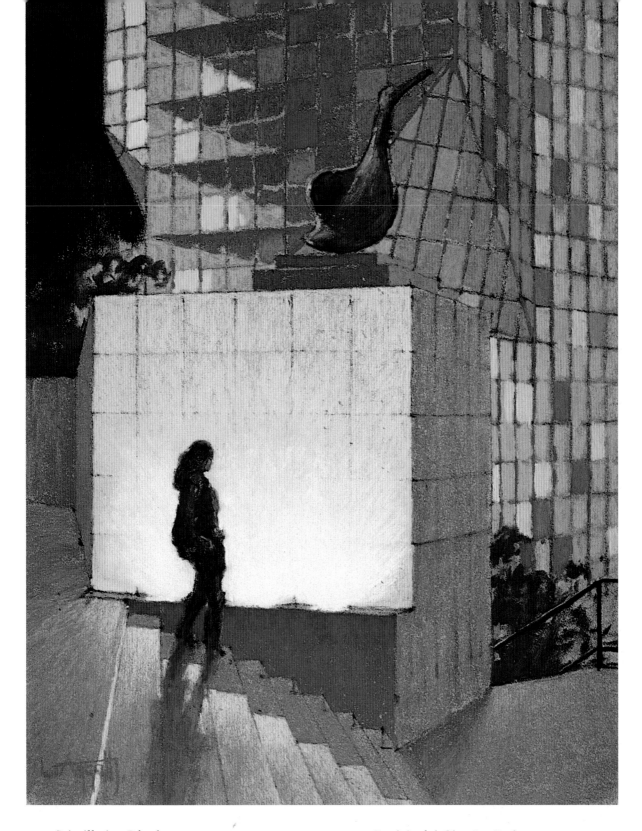

LEFT **Scintillating Rhythm.**
12¾ x 9¾ in (32.5 x 25cm).

ABOVE **Quai André Citroën, Paris.**
12¾ x 9¾ in (32.5 x 25cm).

between the Pont Mirabeau and Pont du Gavigliano forms an attractive visual and practical turning point amongst the array of reflective glass façades. Red earth 6 and blue-violet 18 were used for the sky and the figure. The remainder of the painting was tackled with yel-low-golds and blue-violets. The background curtain of the building was treated fairly loosely, while the corner feature was painted with firmer strokes, becoming even sharper nearer the fulcrum where the intense light clashes with the figure.

THE EFFECTS OF WEATHER AND ATMOSPHERE

The quality of artificial light is affected externally by weather conditions and internally by atmosphere. Being a limited and localized source, it follows that the performance will be impaired by even the slightest effect. Refraction during damp and rainy conditions drastically reduces the performance of vehicle lights fitted with tungsten bulbs (halogen bulbs are much brighter). The conditions of torrential rain, mist and fog, where refraction and deflection are increased by the number of rain or moisture droplets, are even worse at night-time; headlights deflected back from fog, for example. Being a dry medium, pastel does not take kindly to the wet! Mist, rain and fog are therefore difficult to capture outside with pastels even in daylight. Our VW Camper is much used in such conditions!

Internal atmospheric conditions are slowly improving. From the artistic point of view, we will miss the spectacle of smoke rising through the beams of the projector in packed cinemas, the smoke-filtered light of the boxing ring and the snooker table. The smoke-filled and dimly lit club is fast disappearing, the smoky bar has all but gone, and air extractors are coping with die-hard smokers. Internal mood and atmosphere then, is evermore dependent on lighting, décor, design and sound. The two paintings here show the effects of external adverse weather, and internal atmosphere.

RIGHT **Mermaid Street, Rye, Sussex.**
12¾ x 9¾ in (32.5 x 25cm).

FAR RIGHT **Jazz Night, The Jolly Porter, Exeter.**
9¾ x 12¾ in (25 x 32.5cm).

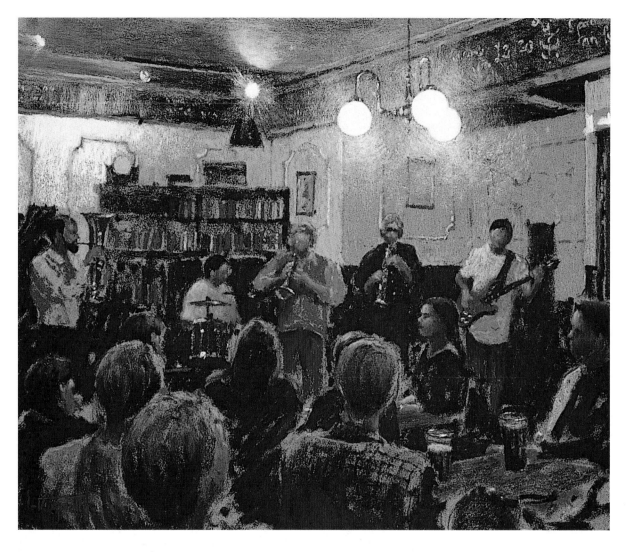

I used grey Rembrandt board for the foggy view of Rye, outside the well-known Mermaid Inn. Earth-reds and greys were used for the buildings and figures and greys for the sky and fog. The centres of the lamps were indicated with shaded yellow-golds, together with the subdued lights emerging from windows. The greys were then blended over the building using flat strokes before the rays of light were extended into the fog with shaded yellow-golds, using flat strokes, taking care not to increase the luminosity too far. Reflected colour from the steps, pavement and road was indicated with shaded yellow-gold. The whole treatment entailed the use of blended passages with soft edges to capture the poor visibility. The brightest areas are the lamps themselves.

Smoke plays a part in contributing to the club-type atmosphere of jazz sessions, with a great deal of ambience produced by the slightly quirky drawing-room décor, lighting and interesting mixed age group. The colour accent in the painting *Jazz Night*, produced on caput mortem red Rembrandt board, is mostly red, brown and yellow, there being very little blue and violet light emitted from a tungsten bulb. Dark shaded earth reds were used together with shaded yellow-golds. Greys were also used, as were blue-violets blended in the shaded areas. I used some blue-violet on the jazz figures to complement the yellows. The lamps were painted with shaded yellow-golds and grey 17 (creamy white) and the haze blended with greys and yellow-golds. The highlights were low key owing to the atmosphere and care was taken not to overdo these. The light source is, however, painted quite brightly in comparison with these highlights.

Chapter 5
THE INFLUENCE OF LIGHT ON COLOUR AND TONE

..

COLOUR

As already mentioned, the time clock or rotation affects the quality of light according to the time of day wherever we are. In this section four different conditions, all linked with the clock, are examined to discover how the quality of light in each affects the way that colour is released from surfaces and ultimately received by our senses. I have used a view in west Penwith, Cornwall, for all four examples so that reasonable comparison may be made. The air is extremely pure at the toe of England, and the light clear and vibrant. Bouncing off the sea on three sides of this narrow peninsula, the sun's rays seem to reverberate with a great intensity. If you are ever in the area look again (for I am sure you do) at the sky.

Cloud definition is usually precise and clear cut, so much so that often their shapes and spaces in between look as though they are part of a jigsaw.

The view is of St Just, looking from the opposite direction to that painted in the example of altocumulus cloud on page 47. The church still dominates this old mining village and the neighbouring mines at Botallack and Geevor can be seen hugging the cliffs behind.

CLEAR SKY
...

In the painting *Clear Sky*, the sky is blue with the afternoon sun emitting good, just slightly filtered, coloured light to be reflected as colour.

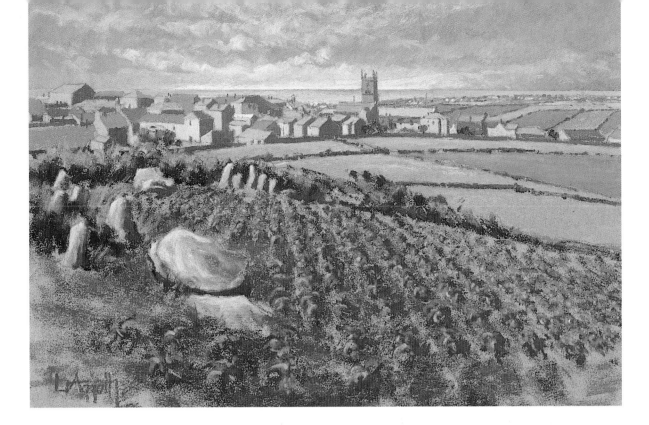

There is good tonal contrast producing sunlit surfaces against clearly defined shadows and shaded areas. There are no vivid bright colours for they are reserved for the boats tied up at St Ives and Newlyn. The typically natural earthy colours are there to be captured though. The earth, young broccoli, granite, rough hedge, stubble, grass and sea all exemplify the characteristics of the Cornish landscape.

I painted the sky with blue-violet 7, 8, 9 and 10, and blue-green 9, 10, 11 and 12, working from the intense saturated hues at the top and lightening towards the horizon, blending with flat strokes throughout. I used blue-violet to indicate the pinky haze near the horizon that pervades the Cornish sky at this time of day. Yellow-gold 12 was delicately blended to the left (the direction of the sun). The sky – the provider of light and seat of the sun – was now set.

The chrome green light Rembrandt paper chosen for the painting provided a good ground for the remainder of the landscape. I registered the darks with unsaturated colours from the shaded areas of each colour range, red earth 6, blue-violet 18, grey and green 13. I indicated some of the lights to the buildings with yellow gold 18 and red 18 before generally working from dark to light.

Shaded unsaturated colours were used for the distance to give pictorial perspective, and more intense saturated hues were employed coming back out of the picture; ie brown earth 8, 9, red earth 8, green earth 10, 11 and green 8, 10 and 12. Roofs, fields and the broccoli leaves deflected the colour of the sky. Finally I completed the lightest lights, adding yellow-gold 12 and red 12, remembering that the highlights were somewhat tempered by the pinkish haze.

OVERCAST SKY

The painting depicting an overcast sky was executed on grey Rembrandt board at more or less the same time of day, but presents an altogether different atmosphere. Agitated cloud in a mixture of warm and cool greys covers the sky. There are signs that perhaps better weather is on the way and a warm ochre glow is emitted from areas where the cloud is thinning. The sun, off to the left, is obviously doing its best to wear down the grey blanket which is acting as a giant filter, and a warm ochre-grey is cast on to the sides of the buildings. The whole painting was achieved using unsaturated colours, ie brown earth, red earth, green earth, green, yellow-gold and grey selected from the shaded pastels of each colour. The landscape generally takes on a greyish hue, deflected from the sky. The tonal extremes are also fairly close together compared with those of the clear sky painting.

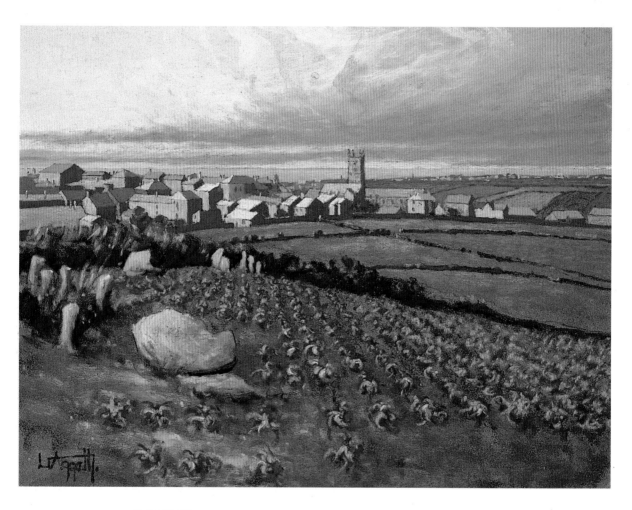

SUNSET
· ·

The moment before sunset sees the sun filtered by a low atmospheric haze and remnants of departing cloud. The resultant reddish-yellow glow envelops everything; it strikes the buildings at a much more acute angle than the light in the previous paintings and chimneys and other projections are picked out in a warm glow. The distant landscape absorbs a lot of the coloured light emitted, but the buildings of Botallack, in contrast, reflect most of the colours of the spectrum received.

Unsaturated, shaded colours were again used for the whole of this painting executed on caput mortem red Rembrandt board: blue-violets,

ABOVE **Sunset.**
9¾ x 12¾ in (25 x 32.5cm).

blue-greens, greys, reds, and yellow-golds in the sky and sea, red earths, greys, blue-violets, and yellow-golds for the two buildings. These colours, plus green earths, greens, and brown earths, were used in the general landscape. These first three paintings illustrate how different lighting conditions have a marked influence on the colour of the landscape. Although the contents have remained constant, there is a considerable change in the colours reflected. Remember, the landscapes will always take on the mantle of the sky, the provider of light and the location of the source, the sun.

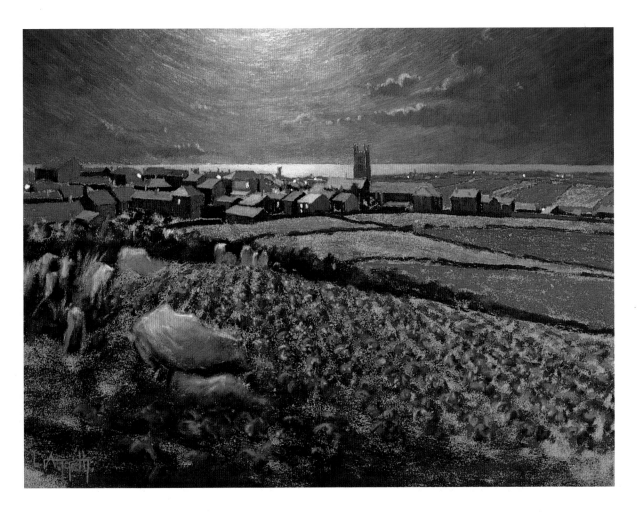

MOONLIGHT

· ·

The phrase 'by the light of the moon' is something of a misnomer, for the light we see in the sky during a moonlit night is really light received from the sun and deflected by the moon. By the time the 'sunlight' reaches earth the amount of coloured light it contains is minimal. Most of this is then absorbed, so the coloured light reflected to our eyes is minimal. Under a full moon as depicted here (although actually out of the picture), deflected light plays a major part in creating mood and atmosphere. Hard, smooth and shiny areas deflect the moonlight and are painted with flat strokes radiating out from this 'secondary source'. The sea, roofs, top surfaces of granite boulders and overturned

ABOVE **Moonlight.**
9¾ x 12¾ in (25 x 32.5cm).

leaves of the broccoli all deflect the steely grey light. The light also faintly illuminates the fields, with the hedges thrown into even deeper shade. Greys and dark, unsaturated colours were used for the painting on a support of grey Rembrandt board. Even the twinkling artificial dwelling and streetlights, which were a joy to add as the 'final touch', are shaded yellow-golds.

The quartet thus completed, we can see how the colours released by surfaces change according to the quality of light they receive. This and preceding chapters indicate that the conditions are continually changing; light is never stable. Colour relationships in Nature are indeed cyclical.

TONE

The light source produces tone as well as colour, and this is always changing. The tonal value of objects refers to their degree of darkness and lightness. There will always be an area in a painting that is darkest and one that is lightest. Areas of medium tone will fall between these two extremes. The quality of light will govern just how far apart these two extremes are.

Light falling on objects enables us to see and record them through tone, in terms of light and shade. We are able, through the correct evalua-

tion of tone, to give them shape. The *direction* of the light source determines the position of light and shade. The angle or *elevation* of the light source determines the length of shadows. As light is constantly changing so, too, are the relationships between tone, light, shade, the appearance of shapes and the shadows cast by them.

The direction of the light plays an important part in determining the amount of drama and contrast there is in a painting. If, for example, we were to choose a view with the sun at our

BELOW **La Felicie, Aix-en-Provence.**
9¾ x 12¾ in (25 x 32.5cm).
Private collection
Situated in one of the narrow streets leading off the eastern end of the Cours Mirabeau, this is a very reasonably priced café frequented by locals, students and visitors. The fenestration and external ambience, under a clear Provençal sky, presented a high-key

subject where saturated colours were deployed. The tonal extremes are far apart, forming areas of extreme tonal contrast tempered by medium-toned passages where reflected light within shadows produces subtle effects. Raw sienna Rembrandt board was used.

OPPOSITE **Dix's Field, Exeter.**
12¾ x 9¾ in (32.5 x 25cm).
Collection of Mr and Mrs C Wright

Early morning autumnal light filtering through the leaves in this quiet Georgian street produces a low-key picture – that is, one in which unsaturated colours have been used and where the tonal extremes are not far apart. The autumn haze, so usual early in the morning and late in the afternoon, acts as a filter to produce soft, subtle interplays of light, shade and colour. I used grey Rembrandt board as the support.

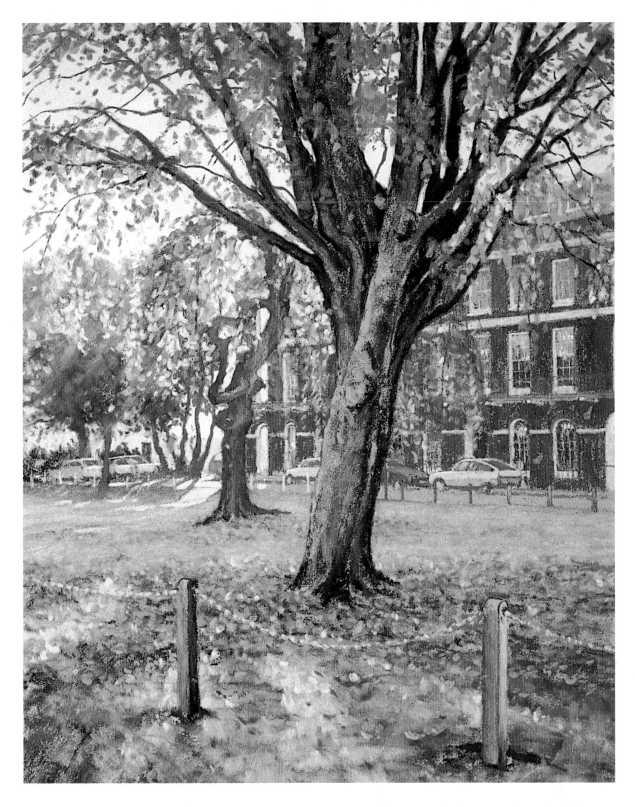

back the colours would no doubt be very strong and bright, but the lack of shadow would provide no tonal contrast. The complete opposite of this is quite literally to turn around 180° and look directly into the sun. This produces the most dramatic impact of all. Shapes are simplified and revealed in the silhouetted form of dark blocks, contrasting against areas strongly lit by glancing reflected and deflected light. Halo effects and highlights will appear around the

edges of figures and objects in deep shade.

Working out of doors to capture these effects is great fun and very rewarding, even if at times the direct exposure can result in a slight headache! Don't be put off though, for as I have mentioned more than once in this book, there is no substitute for the experience to be gained by observing and working out of doors.

It follows that light passing from right angles across your vision produces contrasts somewhere

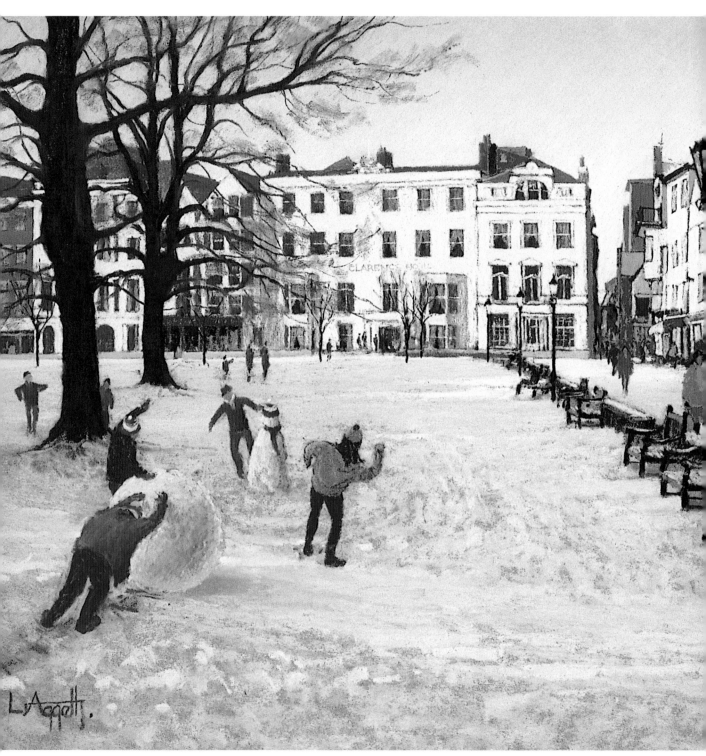

between the two extremes mentioned above, and light delivered obliquely will veer towards either extreme depending on whether it is shining towards or away from the viewer. The elevation of the sun has an influence on the amount of shade and it is generally recognized that more dramatic and lively effects occur either early or late in the day when shadows are longer (see *Winter Shadows*, page 28). Also compare this with *Almond Trees*, page 28.

LEFT **Joy in Winter's Shadow.**
12¾ x 17 in (32.5 x 43.5cm).
The long superstructure and twin Norman towers of the Cathedral Church of St Peter in Exeter are responsible for the long shadows cast by the afternoon sun in Cathedral Close. The huge area of shade covering practically all the ground area and buildings on the right contrasts well with the sunlit hotel at the far end. The small area of dappled sunlight in the foreground provides welcome relief and is, albeit truthful, a necessary touch. If it had not existed I would have been tempted to put it in! The shadow is not a flat colour but comprises many colours, all reflected from adjoining sources; blue-violets and blue-greens from the sky, and yellow-golds, red, and red earths from the buildings. The snow is certainly not white, and deflected and reflected colours rebound everywhere. Caput mortem red Rembrandt board formed the ideal ground for both the tone and hues expressed in the painting.

ABOVE **Overture St James.**
12¾ x 17 in (32.5 x 43.5cm).
Private collection
One of the many studies I have produced of St James's Park, London, Overture is a typical example of a head-on clash with the sun. An added interest are the silhouetted figures seen through the near-transparent deckchairs (which are now, incidentally, in green and white stripes).

It is a midday concert and so the shadows are fairly abrupt. The translucence of the chairs and lit edges around the figures and bandstand canopy form a lively tonal contrast with the seated figures and trees behind. Highlights in the foliage and the light bouncing off the grass add to the drama. For all its vibrancy, the scene, which is painted on chrome-green light Rembrandt paper, is one of relaxed tranquillity – a strange paradox.

Chapter 6
CAPTURING THE LIGHT

· ·

The meaning of light, the light source, and the many influences that affect its quality have been covered in some detail. The paintings depicted amplify the points raised, and some indication has been given as to how the subjects were tackled, together with the (Unison Colour) pastels used to 'describe' the effects. With the basics thus explained it is now time, with the assistance of further completed examples, to take you through some paintings stage by stage to give you some idea of how I approach the problems and challenges of capturing Nature's lighting effects. I do not, I hasten to add, paint in stages, particularly when in full flow, but for the purpose of this book, indeed any demonstration, it is necessary to stop and analyse how one has arrived at a particular juncture. The progress of each painting is therefore presented in three convenient stages.

In this chapter we will investigate how light can be captured under a clear sky, a cloudy sky, through mist and haze, and lastly under stormy conditions.

The examples include plein air paintings, and others painted in the studio using sketches, notes and sometimes photographs (a useful back-up aid, but avoid over-use and sketch whenever you possibly can).

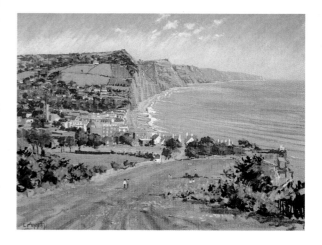

ABOVE **Sidmouth, from Peake Hill, Devon.**
19½ x 25½ in (50 x 65cm)
Collection of Mr and Mrs T A Clarke

· ·

CLEAR SKY

· ·

DEVON FIELDS
· ·

STAGE 1
I used chrome-green light Rembrandt board for this view. The tint and tone of the board are ideal for the early summer patchwork landscape surrounding our studio, where greens and reds predominate.

I ghosted in the composition with charcoal. The path running across the field in the foreground conveniently leads the eye along the hedgerow to the farm buildings at the base of the copse. The fields in the middle distance form a strong converging pattern surmounted by the buildings and copse. The foreshortening of the fields beyond encourages an exploration of the far distance and the forms radiating around the hills return our attention once more to the farm. Once you have developed an 'eye' for composition I think the process is carried out subconsciously. It is, however, useful to analyse the structure of a painting. Composition is one of the elements with which to engage the viewer's interest, always presuming it is the artist's

intention to have something to say, something the work surely will if it possesses any merit at all.

The sky received my attention first for this would set the mood of the painting. Blue-violet 7-10 and blue-green 10-12 were blended with flat strokes lightening down towards the horizon. Blue-violet 1 indicated the slight haze to the left. Although the sky was clear at the start, one or two 'powder puff' clouds developed and I decided to incorporate these in the 'design'. For the purpose of this exercise the sky could still be considered clear, as the effect upon the landscape was unaltered. The shaded sides of the clouds were pastelled with grey 8, 9 and the sunlit areas with yellow-gold 18, 12, red 18 and grey (cream) 17. The far distant hills were blocked in with blue-green 16, 17, before I registered the darkest dark, blue-violet 18, red earth 6 and green 13 to the near hedge. I then indicated the lightest light, yellow-gold 18, red 18 to the sunlit sides of the farm buildings. Using a range of unsaturated blue-greens 1, 2, 3, 4, 5, I established a few mid-tones by positioning the wooded areas and some hedges. The tonal range was now set and together with the distant blues a suggestion of pictorial perspective already achieved.

STAGE 2

I proceeded with the distant fields, gradually working my way to the foreground and out of the picture, blocking in areas of base colour. Shaded blue-greens 16, 17 gradually gave way to shaded unsaturated greens, 4, 5, 16, 17. Shaded reds 16, 17, red earth 2, 3, 14 were used for the ploughed fields. More intense saturated colour was used for areas nearer the foreground, ie green 8, 9, 10, green earth 12, 11 and red earth 9, 8.

The trees and hedgerows were further developed with shaded blue-greens, blue-violets and greens, before the light and shaded faces of the farm buildings were produced with flat strokes of grey 7, 8, 9, 10, 11, 13, 3, red earth 2, 14, 8 and yellow-gold 18.

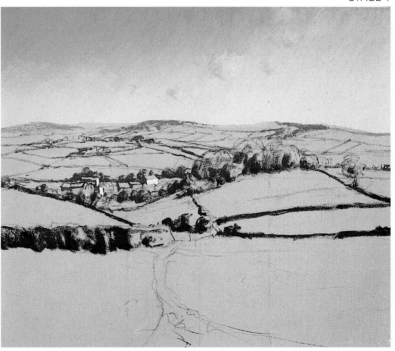

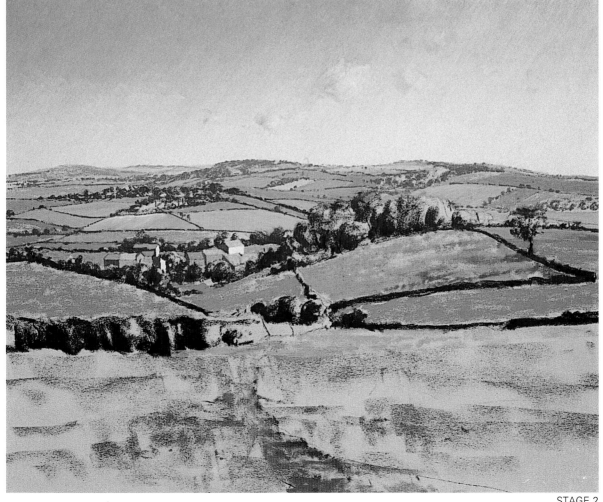

STAGE 2

Devon Fields.
15¾ x 19½ in (40 x 50cm).

STAGE 3
The rounded forms of the patchwork fields were accentuated through the addition of lighter shaded colours. These increased in intensity the nearer I worked back out through to the foreground. Sunlit sides of trees and hedgerows were indicated, again using less intense, unsaturated and shaded colours the greater their distance from me. The important deflected light from the sky was added to the fields, hedgerows and trees with lightly applied flat strokes blending blue-violet 8 and 9 over existing colours. This is a delicate operation and I took care not to overdo things. Highlights were finally applied to foreground grasses and hedge, yellow-gold 18, 12 and grey (cream) 17.

Under a clear sky where there are no large clouds to cast shadows over the landscape, which produce contrasting areas of light and shade, a painting relies more on pictorial perspective to provide depth of contrast. I was satisfied that the painting achieved this, and together with the juxtaposition of reds and greens a reasonable harmony was accomplished.

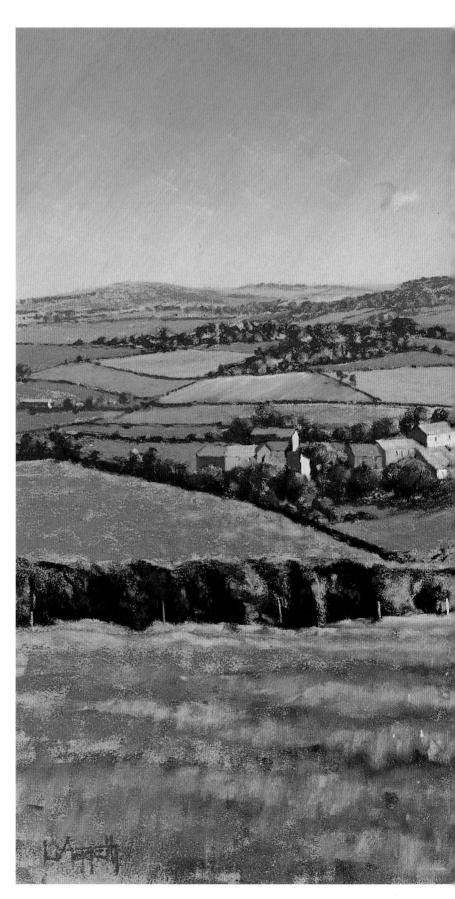

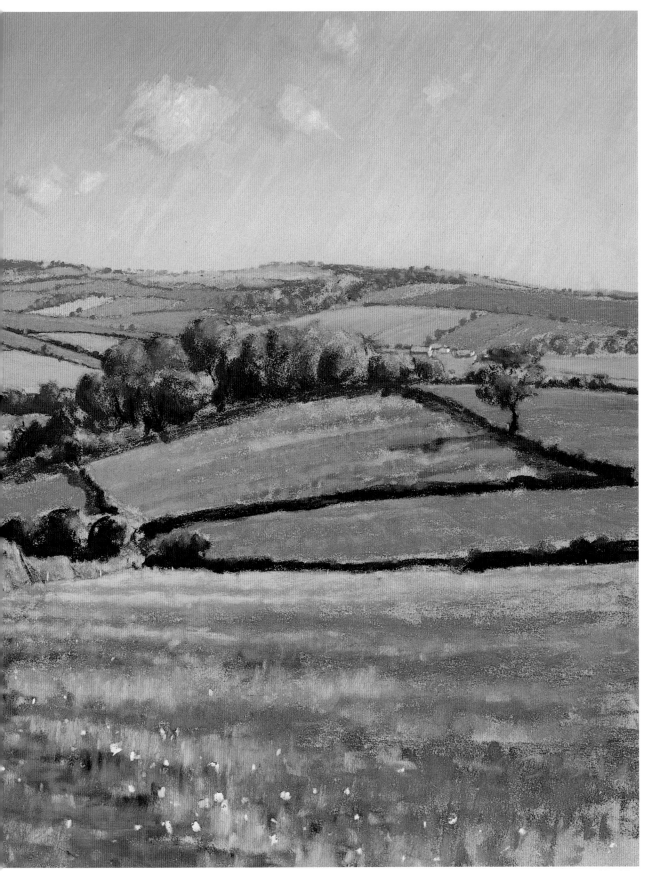

STAGE 3

CLOUDY SKY

ILE TUDY

STAGE 1
There is no doubt that seeking out locations with different lighting conditions and topographical character fires the imagination. I also feel that a desire to capture these qualities truthfully will hone your creative response.

The over-use of one palette may inhibit the ability to adapt – travel will help to keep this from becoming a problem. One need not go far: adjoining counties, or even adjoining parishes, are often quite different. Brittany, the subject of this demonstration, is different from Cornwall despite the Celtic similarities. Cumulus clouds moving fairly quickly across the sky provide dramatic contrasts of light and shade in the peninsula village of Ile Tudy in Finistère, across the river from Loctudy. I completed the sky first using the range of intense blue-violets and blue-greens. Shaded blue-violets, greys, yellow-golds, earth reds and reds were used for the clouds. The hills further up the estuary were pastelled with blue-violet 13, 14 and blue-green 4, 5 and 6.

STAGE 2
I proceeded to block in the shaded surfaces of the buildings including those on the far left in cloud shadow using grey 7, 8, 9, 10 and blue-violet 13, 14, 15, blending brown earth 16, 15 and red earth 14, 15. The trees, blue-green 1, blue-violet 18, green 13, were then registered. Sunlit surfaces were added using the same colour as before plus brown earth 7, 8 and yellow-gold 18, 17 for granite façades and gables. The remaining boats were blocked in to accompany the nearest, established in Stage 1. I then introduced some perspective in the water with shaded strokes of blue-green 1 and green 2.

Ile Tudy, Finistère, Brittany.
12¾ x 17 in (32.5 x 43.5cm).

STAGE 3 (overleaf)
I applied green 14, 15 to the trees under cloud shadow, on the left, to give a hint of form. Further strokes were applied to the sunlit trees with green 15, 9 and 11. Yellow-gold 17 was applied to the beach area before the water, agitated by the breeze, was developed. The cloud shadow to the left was pastelled with blue-green 1, 2 and blue-violet 17 before I continued with blue-green 1, 2 and blue-violet 18 in looping expressive strokes to produce 'wave' movement. I gradually built up these adding green 2, 3, blue-green 4 and then blue-green 10, working from dark to light.

Warmth was added to the sunlight on the walls of the buildings with yellow-gold 12, and red 12, both carefully blended in with flat strokes. The roofs were similarly treated with brown earth 9. Reflections in the water (deflected light from the clouds and buildings) were added, using similar looped strokes with yellow-gold 18, grey 17 (cream) and blue-violet 13. These were carefully but freely blended to ensure the reflections were darker in tone than the colour of the source.

The bright red mooring buoys were added, and then the fenestration and chimney details were suggested to buildings. The figures on the beach were then registered before the final touches of deflected light from the sky were added to the water with blue-violet 7 and 8.

The compositional interest commences with the foreground boat, leading in to the point of extreme contrast between shaded trees and sunlit building, up into the clouds, back down again, to the terrace by the traditional stepped gable and to the right. The buoys lead the eye to the left again. An interesting self-analysis it may be, but painted subconsciously I can assure you!

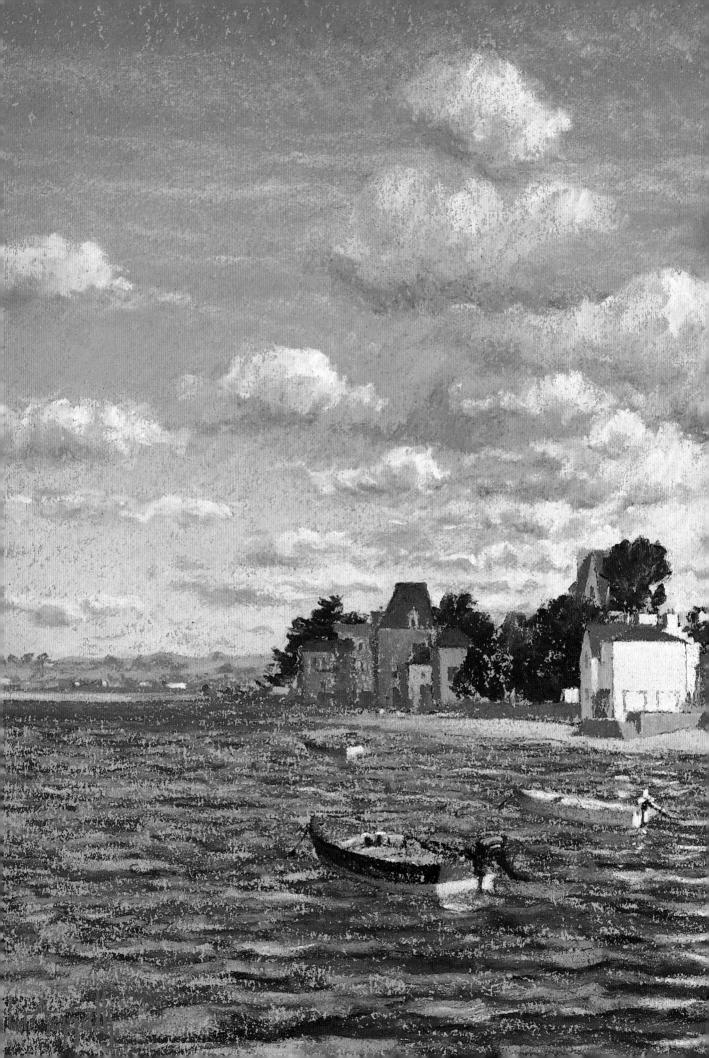

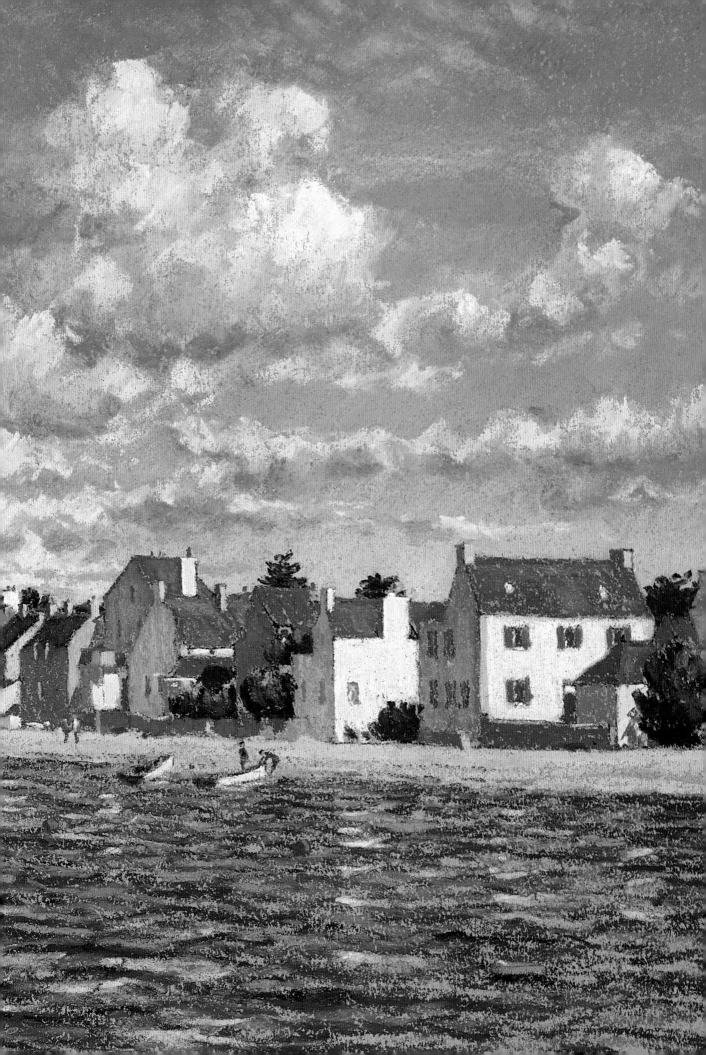

MIST AND HAZE

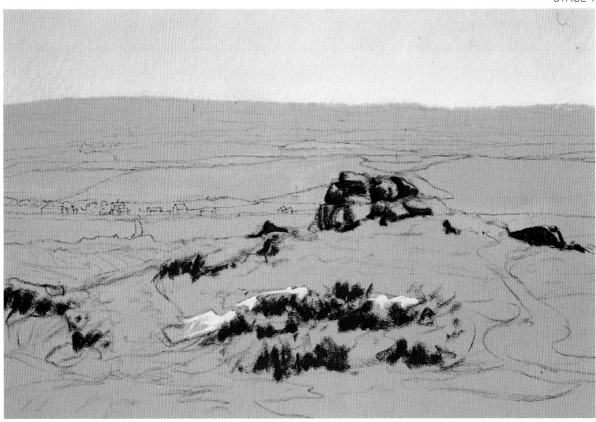

CARN BREA

STAGE 1
The strangely luminous filtered sunlight through a haze which seems to marry sky, sea and land together is often experienced in west Cornwall. On a clear day one can look down from Carn Brea, the last granite outcrop, over the last piece of England and beyond the Longships to the Isles of Scilly.

I chose chrome-green light Rembrandt board and lightly indicated the composition in charcoal. I then went straight for the sky, blending blue-violet 7, 8 and blue-green 12 down to the approximate extent of the land mass. I skipped the sea for there was nothing to see. The darks were painted next, the shaded side of the granite outcrop with red earth 5 and grey 18, 12. The shaded areas of heather and gorse were blocked in with green 13, red earth 6 and blue-violet 18. Granite deflecting light in the foreground was registered with grey 11 and 17 so that the lightest lights and darks were now set.

STAGE 2
It was important that the tonal relationships already set were maintained whilst tackling the distant landscape below. The potential drama to be explored in this painting would only be realized if the airy contrast between the immediate vicinity and the vast, seemingly infinite space beyond were successfully captured.

The far distance was blocked in with broad flat strokes using blue-violet 13 and blended with blue-green 6 and 17 nearer the foreground. The lighter fields, stripped for hay, were pastelled with green earth 13 and yellow-gold 18. Field shapes were then suggested with the same colours applied light over dark. The ploughed areas were indicated with red earth 3, 2, before hedges were applied with expressive line strokes of blue-violet 15, 14. The shaded surfaces of the buildings in Crows-an-Wra were suggested with grey 10 and blue-violet 15. Returning to the sky I blended blue-violet 1 to capture the darker area of haze on the right, taking delicate flat strokes down across the landscape and taking care to leave just a hint of where land ends. I did the same on the right with blue-violet 7 and 1, this time obliterating the land extremity in the area above the granite. I then worked on the foreground with shaded greens developing the form of the vegetation. More body was applied to the granite 'sculpture' using grey 8, 9 and 14.

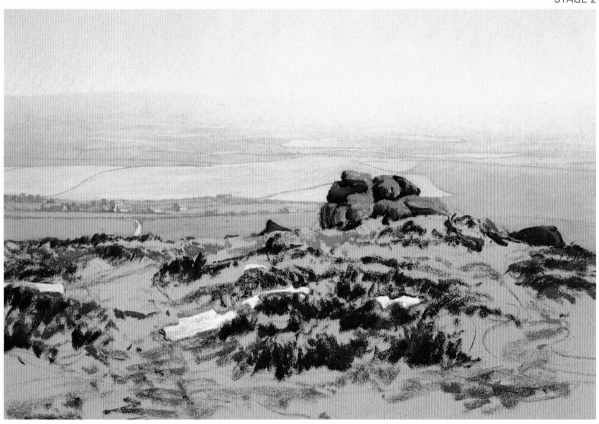

Carn Brea, overlooking Crows-an-Wra, West Penwith, Cornwall.
12¾ x 17 in (32.5 x 43.5cm).

STAGE 3 (overleaf)
I applied delicate, blended flat strokes of blue-violet and red 18 to the fields where the patches of filtered sunlight were at their strongest. The sunlit surfaces of the buildings were added, with yellow-gold 17, 18, and red earth 1 to walls and blue-violet 1, 13 and grey 11 to roofs. All are shaded colours as the sunlight is not intense, but filtered.

Some more intense colours were applied to the foreground where the light is less affected by the haze and I developed the grass, gorse and heather with bold, free strokes. Highlights were added to the granite using mostly shaded colours, red earth 1 and yellow-gold 18, although I used blue-violet 7 together with 1 for deflected light from the sky. Suggested detail – grasses, bracken (red earth 1, yellow-gold 18, blue-violet 7) and gorse bloom (yellow-gold 10, 11) – were finally registered with line and pointillist strokes.

The eroded footpath on the left leads the viewer down behind the granite outcrop and into the vast openness to the point of 'infinity' above the rock, and the eye is then contained by the shaded boulder on the right before being brought round to the foreground and to the point where the path 'meets' the road leading to the village. Movements within the painting such as this, and there should be others, encourage the viewer to enter and explore the relationships enjoyed between artist, Nature and landscape.

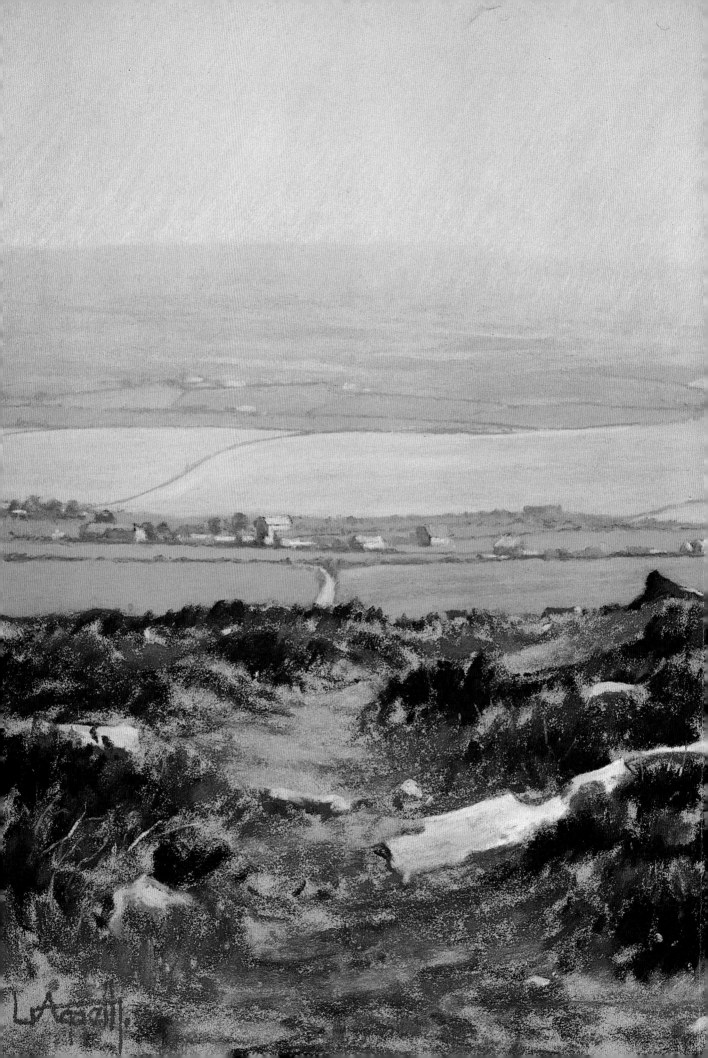

STORMY CONDITIONS

Approaching Storm, Ouistreham, Normandy. 9¾ x 12¾ in (25 x 32.5cm). *Four hours after I captured this angry scene we were due to catch the ferry from the port of Ouistreham to Portsmouth! Fortunately, by the time we had enjoyed the last cordon bleu meal of the holiday, cooked by le chef* d'artistique *in the Camper parked to the right of this scene, the storm abated.*

Cumulonimbus clouds and their associated weather conditions are indeed quite spectacular. Those in Approaching Storm *had not quite reached the dizzy heights where the anvil shape is formed although the familiar wispy effect can be seen devel-* oping on the right. The sun is almost directly behind, just off my left shoulder. Although the beach huts are therefore seen in flat colour, the ground shadows produced by the cloud, and the dark purple-grey of the cloud base, form a lively contrast, heightened by the perspective of the path, beach texture and cloud form.

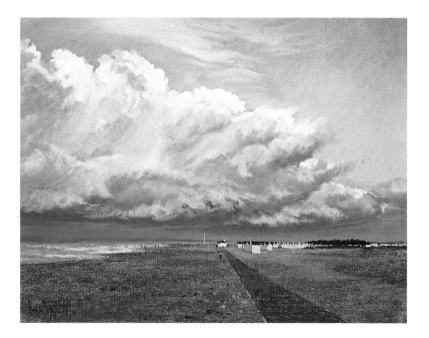

STORM AT LESCONIL

STAGE 1

Whereas the previous demonstration was spectacular, this one could be described as frightening for winds of hurricane force lashed the Brittany coast tearing boats from their moorings and causing much damage. It was virtually impossible to stand against the full force of the wind and the Camper was buffeted and peppered with sand, grit, seaweed and various marine objects. This painting was therefore completed in the studio with the aid of sketches, notes and photographs, plus observation.

It was a September evening and the sun was dropping in the sky. The cloud seemed to be dense and yet to the west it would thin out momentarily to allow a strangely warm faint filtered light to deflect from the foaming brine before closing in again. It was so dull that at times the wind-torn, phosphorescent froth seemed to be the main source of light.

The main composition was lightly charcoaled before I painted the sky, for as always this set the tone. This and the distant headland with buildings were pastelled entirely with a selection of warm, cool and purple-greys. Light areas, the gable ends of houses and faintly luminous area in the sky, were registered with warm grey and shaded yellow-gold 16, 17. The outer harbour wall was positioned with grey 14 and the foreground rocks with earth red 6 and grey 14.

STAGE 2

I now concentrated on laying-in the base of the boiling sea. Working from dark to light I applied broad flat strokes of grey (green) 2, 3, and then grey 4 to lighter passages. I used grey 14 and green earth 6 to darken the wave troughs off the end of the harbour wall to the right. Green earth 5 and 6 were blended to the few areas where there was little or no froth. I then began to build up the wind-torn waves and white sea with grey 4, 5, 6 and yellow-gold 16 and 17. The pastel strokes, mostly flat at this stage, were always made to follow the form, movement and direction of the waves. I was conscious of the tremendous energy created by the wind, the waves against the harbour wall, and the raging receding current flowing left to right, against the incoming broken wave, whipped and lashed by the wind from the right.

Storm at Lesconil, Finistère, Brittany.
9¾ x 12¾ in (25 x 32.5cm).

STAGE 3
It now remained to place the final accents on to the foaming water, highlights where the churning, hissing, incandescent broth deflected the weak, transient sun.

I indicated the spray whipped by the wind from the tops of the waves with feathered flat strokes (ie releasing pressure at the end of each stroke) using grey 5. I then introduced grey 11, 17 with further applications of yellow-gold 18 blended with red earth 18 to suggest detail in the churning cauldron, and waves crashing against the wall. The final highlights were produced with a sharp twist of the pastel stick. The last mark made was the red post at the end of the harbour wall.

STAGE 3

IN SEARCH OF LIGHT

. .

Travel, necessary for expanding an artist's horizons, may not be everyone's desire; however, the journey does not have to be very long. A visit to the next village, town or county will provide a change of terrain sufficient to inspire an artist and recharge his or her creative batteries. You do not need to cover long distances in order to experience different lighting conditions either. In my own county, the quality of light varies considerably from area to area, particularly towards the end of the day, owing to the local topography.

In this chapter I am inviting you to join me in my quest to capture the quality of light, mood and character of the areas visited. They are all renowned for their vibrancy of light, but nevertheless are different from one another. So, hop aboard, bring your equipment and enjoy the break.

. .

CORNWALL

. .

The light is most vibrant right at the bottom tip of Cornwall, in west Penwith, where the peninsula is at its narrowest. This is due partly to the close proximity of the sea on all three sides in relation to the land mass. Light deflected by the water reverberates round and round. The other parts of Cornwall enjoy a clear quality of light, each area possessing its own character under the Kernow umbrella. The soft green area below the Tamar, the north coast, Roseland peninsula, Fal

and Helford creeks, and the Lizard are all differ-
ent. Although I had visited the county yearly
from my youth it was not until we lived in Truro
that I really got to grips with all that beautiful
rugged scenery season by season. Strange though
it may seem, I tended to turn my back on the
coast to concentrate on the mystique of the hin-
terland. We now visit west Penwith at least once
a year to work and it is there that all my inspira-
tional feelings become well and truly fired up.
The small fields with Cornish drywalling, stones,
mines, granite outcrops, the sculptural quality of
the coast, villages and the colour of the harbour
scenes, all illuminated by a clear vibrant light
emitted from an expansive sky, are truly an inspi-
ration. The following examples and demonstra-
tion are subjects from this part of the Duchy.

The view from immediately above the road
between St Ives and Zennor, *Penwith Landscape*, is
typical of the many elevated panoramas along the
coastal journey to Land's End. Well-defined
clouds, their colours deflected by the sea, drift
slowly by, and others cast their shadows across
the great sweep from the Crow's Nest to the sea.
The clear light defines quite strongly the dry
granite walling describing the patchwork of
fields. The light from the sky is deflected by the
landscape generally, and particularly by the sunlit
bracken and gorse in the foreground. I used
chrome-green light Rembrandt board.

In *Evening Light, Sennen*, a typical Cornish
haze acts as a filter to produce a glow which per-
vades the whole painting. Looking towards the
sun, the subject glistens with shimmering,
deflected ochre light. Blue-greys tinged with
violet produce subtle complementary contrasts
with shaded yellow and orange. This was paint-
ed on grey Rembrandt board.

LEFT **Penwith Landscape.**
19½ x 25½ in (50 x 65cm).
Collection of Mr and Mrs P Evans

BELOW **Evening Light, Sennen.**
9¾ x 12¾ in (25 x 32.5cm).
Private collection

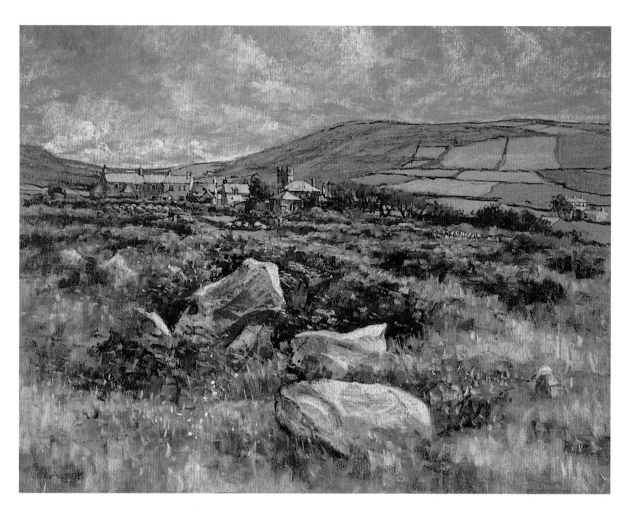

ABOVE **Zennor.**
19½ x 25½ in (50cm x 65cm).
Collection of Mr and Mrs J F Laurence

Just beyond Zennor village and past Giant's Rock lies the beautiful National Trust property of Zennor Head and Porthzennor Cove. From there is visible this inland view of the village which I painted on site not far from Giant's Rock at the end of the track. Using a sepia ink underlay, applied with a brush on grey-green Ingres paper, I quickly established the darks. I then recorded a moment in the rotation of colour, for the light emitted from the showery sky was continually on the turn. The colours reflected convey the achromatism or pigment deficiency that occurs at the end of a hot season just before the autumnal hues begin to appear.

HIGH SUMMER, SENNEN COVE

Whitesand Bay and Sennen Cove seem to cradle the light along this part of the Cornish coast. The huge sweep of white sand from Aire Point flanked by an emerald and blue-violet sea on one side and dunes, granite boulders and grassed cliffs on the other seems to deflect light in all directions. When deserted in winter, the size of the space is difficult to perceive, but during high summer, however, the subject of this demonstration, holidaymakers and locals provide a sense of scale. From midday onwards, looking towards Sennen Cove with its granite, rendered and slated buildings, the light pierces semi-translucent windbreaks, produces haloed silhouettes and is deflected off smooth surfaces to present a jangling of colour.

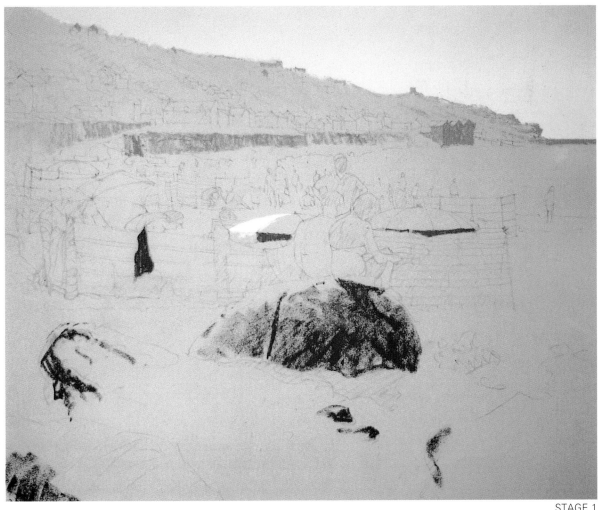

STAGE 1

STAGE 1

Choosing raw sienna Rembrandt board as a sympathetic support for the subject matter, I ghosted the composition and then dusted off the excess charcoal before tackling the sky. My intention was to complete this area first, for then the mood would be set.

The sun was still quite high in the early afternoon sky and light blue-violets predominated, lightening further still down to the horizon to merge with a pink-ochre haze. Light deflected from the Western Approaches beyond Pedn-mên-

du and Land's End bounced back from the sky. I blended several colours, blue-violet 9, 8, 7, 1, blue-green 11, 12, working down to merge with grey 17 (cream) and red 18.

The darkest darks, red earth 6 and blue 18, were applied to the coat and shaded granite boulders, followed by the lightest light to the umbrella, grey 17 and red 18. I then added a few mid-tones, grey 8 and 9 to the cliffs, harbour wall, and lifeboat station. The 'light source' and tonal range were now set and a sense of pictorial perspective established through tone.

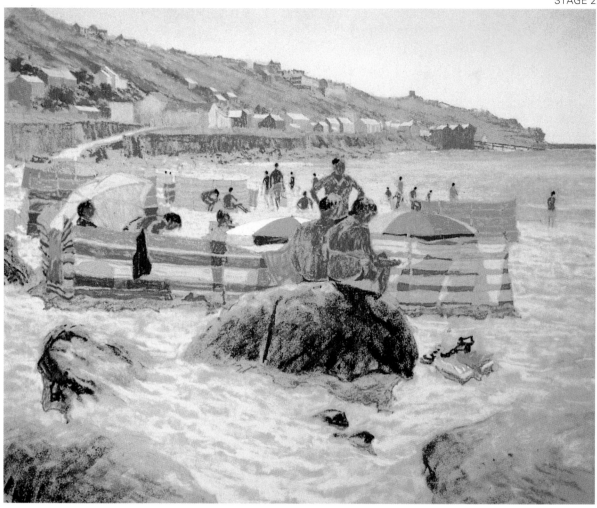

STAGE 2
I worked gradually back out of the picture from distance to foreground. I decided to use the colour of the support in the final painting, and with this at the back of my mind I developed the shaded areas of the village, foreshore and cliffs using grey 11, 9, 8, 7 (purple and blue-greys) and blue-green 13, 14, 1, 2, 17, 5 and green earth 12, 10. I then established the tonal contrast between the rocks and figures silhouetted against the sunlit beach and sea. The translucent windbreaks were blocked in with flat colours, all fairly low key at this stage, for the painting is gradually progressing through dark to light.

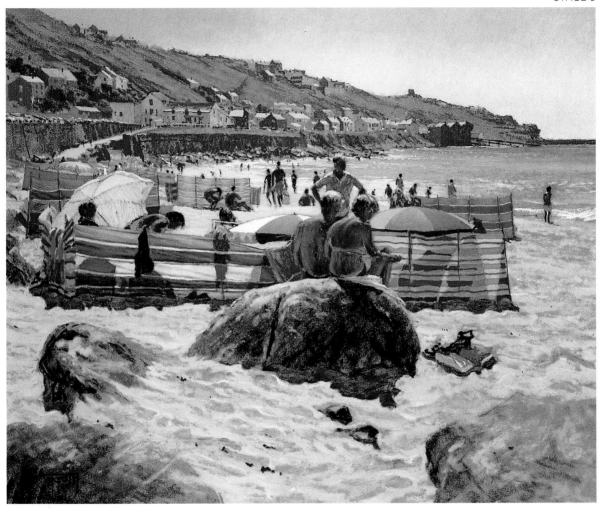

High Summer, Sennen Cove.
15½ x 19½ in (40 x 50cm).

STAGE 3
I continued in this vein lightening the sand and developing the translucency of the windbreaks and umbrellas before adding further detail along the beach. I then positioned the shadows, short in length from the high sun, using a mixture of blue-violet 16, 17, 18 and grey 1, 2 with delicate flat strokes of yellow-golds, and reds to indicate reflected and filtered light.

Highlights produced by the deflected light were added to the sloping roofs, silhouetted figures and granite boulders. Light strokes of blue-violet 8 and blue-green 12 were applied to the headland, following the contours, to depict the reflected light from the sky.

The drama of this subject revolves around the vibrancy of deflected light, bouncing from various surfaces, and the direct light filtered through the windbreaks. Although the painting is full of vibrant light, emphasized by red-green, blue-orange and yellow-violet combinations, the accent on shade leans towards the blue-purple-grey associated with Britain's maritime climate and landscape.

BRITTANY

Like Cornwall, Brittany is full of mystery and light. Most of the saturated, vibrant colour is also to be found in the harbours, not forgetting the tulips of Tronoën. The general character is constituted from the rivers, granite moors, stones, harbours, architecture and ancient customs. Nowhere is this more apparent than in Cornouailles, the area favoured by many artists including Paul Gaugin, Emile Bernard, Emile Jourdan and others. From Le Pouldu in the east to Audierne at the western end near the Pointe du Raz, painters settled to work. Pont-Aven is perhaps the most well known, but artists are attracted to the whole of this area which is subjected to varied moods generated by the ever-changing luminosity.

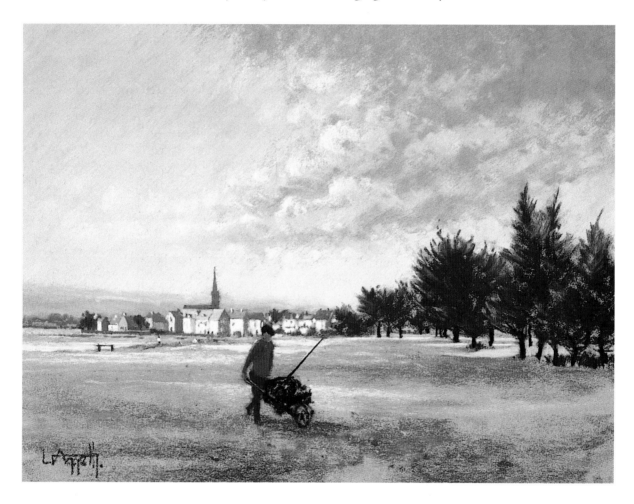

ABOVE **The Seaweed Collector, Ile Tudy.**
9¾ x 12¾ in (25 x 32.5cm).
Situated in the Pays Bigouden, Cornouailles, Ile Tudy is almost surrounded by water at the mouth of the Pont-l'Abbé river. The character in The Seaweed Collector *on the sea-ward side was presumably making some preparation in his garden for future crops. He made no fewer than a dozen journeys during the morning and a few more after lunch. I'm not sure how far he had to go, but he paced himself very well. Moving into the foreground area of shade he forms a contrast with the sunlit dunes and buildings. There is quite a strong compositional counter-balance between the foreground shadow, figure, fir trees on the right, and the sunlit sea, sand, buildings and swept edge of the clouds. This was painted on grey Rembrandt board.*

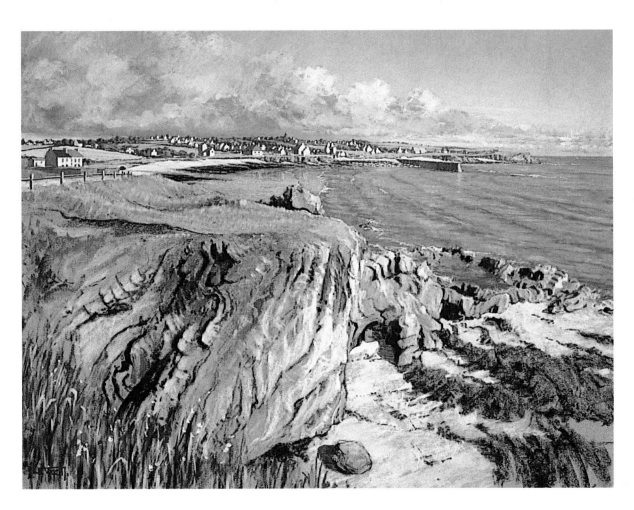

ABOVE **Anse du Loch, and the village of Primelin, Cornouailles.** 19½ x 25½ in (50 x 65cm). *Situated not far from the Pointe du Raz at the far western tip of Cornouailles, Anse du Loch embodies all that this area has to offer in terms of light, character and mood. The late afternoon September light, 'warming' the edges of the retreating clouds, and illuminating the traditional white and granite quoined gabled ends of the buildings against areas of shade, epitomizes the quality of Breton light. The somehow scaled-down cliff face belies the nature of what there is in store further along the coast. The ruggedness of the rocks, however, bears testimony to prevailing conditions of later months. I used grey Rembrandt board as the support.*

FISHING BOATS, CONCARNEAU

Situated on the 'Routes des Peintres' (Painters' Trail), Concarneau, in la Baie Forêt, Cornouailles, is the third-largest fishing port in France. The harbour is usually alive with activity and colour. The boats 'absorb and reject light' to project painted, brilliant, intense colours. There is always movement, both from and within the vessels. The deflected light from the water also flickers across the many textured surfaces.

There was not a great deal of movement on board *L'écume* for her fishermen were taking a long and no doubt well-earned rest, peeling and cutting thin slices of garlic with their knives and downing them with slurps of vin rouge.

STAGE 1

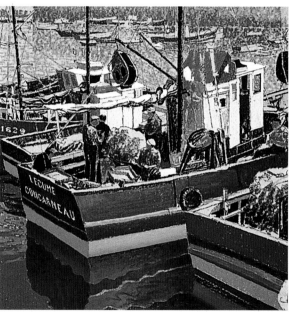

STAGE 2

STAGE 1
Using HCAB-Longlife P400 Cabinet paper for the support which gave a warm pinky-grey ground colour, I drew the busy composition carefully in charcoal and then sprayed fixative so colours could be pastelled over without becoming darkened. (Pastel will lift charcoal so either dust off excess or use fixative.) I registered the darkest darks with red earth 6 and blue-violet 18 and then the lightest lights using yellow-gold 12, grey 17 (cream) and red 12.

STAGE 2
I worked on the distant wall of the Ville Close (old walled town) and patch of sky and buildings to the left, working from the back to the front of the painting. I treated this area quite loosely, applying broad flat strokes of blue-violet 15, 16, red earth 3, 15 and brown earth 15 to the wall which was in shade. Mid to dark tones of the distant boats were indicated along with lights to establish the level of tone at this distance, and in contrast with the wall. The movement of light on the water was portrayed with short strokes (some overlapping and others side-by-side) of blue-violet 13, 14, blue-green 5, 6, red 18 and yellow-gold 6. Returning to the boats, I worked on the darks and half-tones building up form and tonal relationships. The clean shapes of the hulls and their reflections provided a simple, uncluttered base, offsetting all the paraphernalia on deck. Their bright complementary colours made a considerable contribution to the lively scene, too. I used blue-violet 18, 6 and 15 for the shaded stern of *L'écume* and the same colours blending from the base to blue-violet 5, 4 and 3 on the sunlit side. Blue-violet 14, 13 were used just above the waterline. The complementary line was indicated with yellow-gold 7 and 9, and the shaded lettering with yellow-gold 16. The water and reflections were pastelled using blue-violet 16 and 15 for the reflected sky and a combination of the previous colours used for the boat reflections, including green 13, 15, ensuring that the reflections of dark areas were lighter in tone, and the lighter areas darker in tone. The other hulls were similarly treated using greens and reds, before I added a few more lighter passages to the superstructures of the boats.

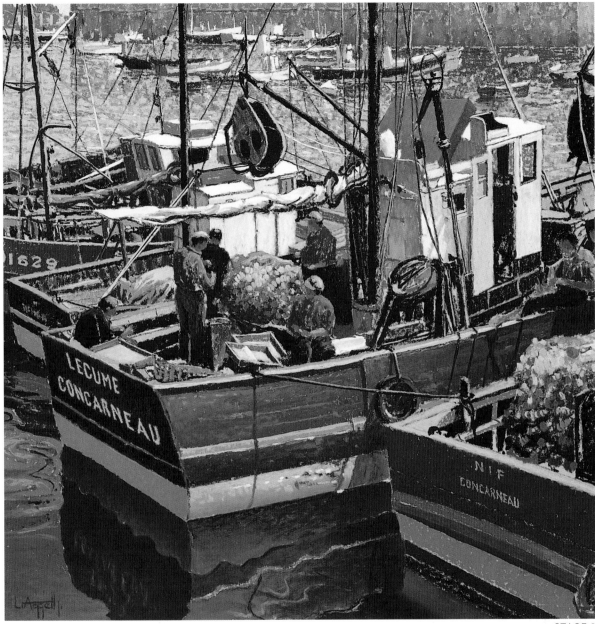

STAGE 3

Fishing Boats, Concarneau.
19½ x 19½ in (50 x 50cm)

STAGE 3

The pastelling from now on gradually brought the painting to life. Highlights were added to the distant boats, providing a contrast against the shaded wall. Light and shaded reflections were painted with further short strokes. Areas of

reflected light were blended to shaded areas, eg the rear of the wheelhouse to *L'écume*, where red earth 15, 14 and red 17 were applied with flat strokes. The rigging was suggested with delicate line strokes before the finalization of shadows and highlights. Almost every surface, edge and arris deflected light from both the sky and adjoining colours.

Blue-orange, yellow-violet and red-green complementary combinations contribute to this symphony of light.

BEAUJOLAIS

It is a sheer joy to work in the vineyards of Beaujolais. I refer to the Beaujolais 'crus' where the best wine is produced. The area lies immediately to the west of both the N6 and A6 below Mâcon and above Villefranche. Hardly a square metre of space is wasted. There are 10,000 plants per hectare (one plant per square metre) around the crus villages of Saint-Amour, Juliénas, Chénas, Moulin-à-Vent, Fleurie, Chiroubles, Morgon, Régnié and Brouilly. The people are relaxed and friendly, and the pride taken in their viticulture is almost entirely responsible for the character and atmosphere of their countryside. The climate is kind to the gamay vines and the clear but sometimes softer light illuminates the pink granite hillsides, and the sandstone and pebbles the vines are grown on, to produce lively complementaries. The fresh greens of young growth develop later into the multicoloured cloak of the vendange.

Fleurie.
19½ x 25½ in (50 x 65cm).

Fleurie wines, because of their flavour and natural distinction, are known among the Beaujolais crus as the Queen of Beaujolais. Fleurie is roughly in the centre of the crus villages, and makes an ideal base. The well-landscaped municipal campsite lies on the east side of the village. In September during the vendange you do not need to open a bottle for the aroma from the local co-operative press is quite intoxicating. The painting below, produced on light oxide-red Rembrandt board, shows the operation carried out in Fleurie in late June, where the rapidly growing vines are tied two-thirds of the way up, immediately prior to trimming (see the painting of Saint-Amour on page 53). The morning light bounces off the roofs and ricochets through the vines. The brightly clad locals working towards the sun are thrown into silhouette and edged in deflected light. The light produces strong tonal contrasts together with lively red-green complementaries, pink sand and yellow-green sky, vines and buildings.

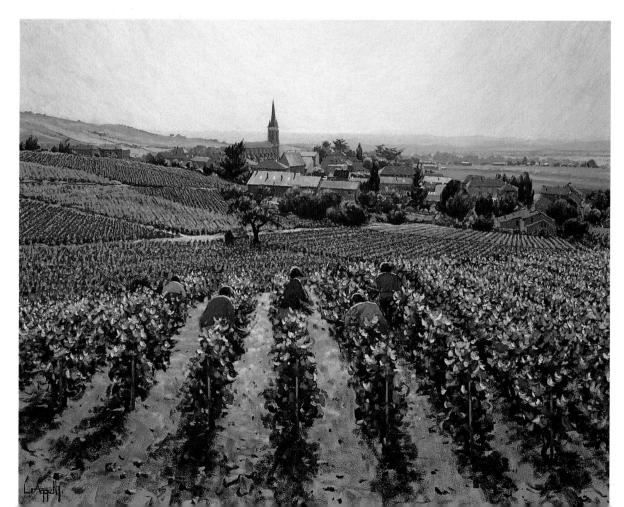

CHÉNAS

Chénas lies north-east of Fleurie, just over the hill, and quite close to Moulin-à-Vent (a subject I have painted many times from different angles). The village is very picturesque, as indeed are all the crus villages, with vines practically growing up to the front doors of the dwellings. It is again late June but here the vines have been bunched and trimmed, producing the authentic goblet shape which is also (and mostly) determined by severe pruning each year.

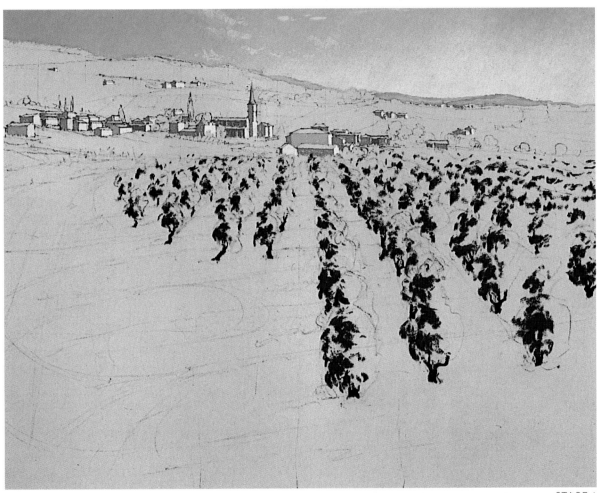

STAGE 1

STAGE 1

I chose light oxide-red Rembrandt board for I intended the support to do some work for me in view of the amount of pink sand in the foreground. I barely ghosted the composition, just the outline, before concentrating on the sky which was clear apart from one or two wispy clouds. The strong blue, particularly to the left, was painted with overlapping, blended flat strokes of blue-violet 10, 9, 8, 7 and blue-green 9, 10, 11 working strong to weaker hues from the top towards the horizon. The light clouds were indicated with blue-violet 13, 14, yellow-gold 18, red 18 and grey (cream) 17.

The distant hills were blocked in with blue-violet 13, 14 and blue-green 5, 6 before I registered the darks of the vines, green 13, blue-violet 18 and red earth 6. The perspective, an important element in this painting, led me to the village where I blocked in the building forms with halftones using blue-violet 14, 15 and 16. Yellow-gold 18 and red 18 were used to indicate a few of the sunlit surfaces.

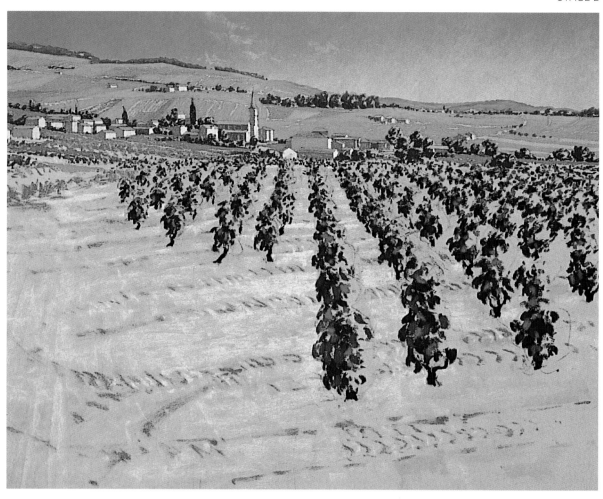

STAGE 2

The vineyards on the hill slopes were blocked in with flat strokes, green 3, 4, 5, green earth 11, 10 and blue-green 5, 16 and 17, always following the direction of the contours and linear arrangements of vines. Tracks and areas of sand were left plain for the time being. Trees were indicated with blue-green 1, 2, 13 and blue-violet 17 denoting shaded areas, and decreasing in tone the further the distance. The sunlit sides were just suggested at this stage and still using shaded, unsaturated colours, green 4, 5, and 14, 15. More work was carried out to the buildings, sunlit faces, red earth 1, 13, yellow-gold 18, 17 and red 18. Roofs were added red earth 3, 2, 7, 8, 9, brown earth 8 and red 16. Reflected light to shaded faces was applied with red earth 14, 15 and yellow-gold 17, 16.

Greens of a more saturated nature were used to indicate the vines to the left and immediately in front of the buildings: green 2 for the shaded areas then 8, 9 for sunlit areas. These were applied in short strokes leaving directional touches of the pink support.

I began to develop the sandy base, brown earth 16, 9, 8, red earth 4, 7, suggesting tractor marks and light area. The goblet shapes of the vines were then taken a stage further, working from dark to light, green 1, 2 and 7.

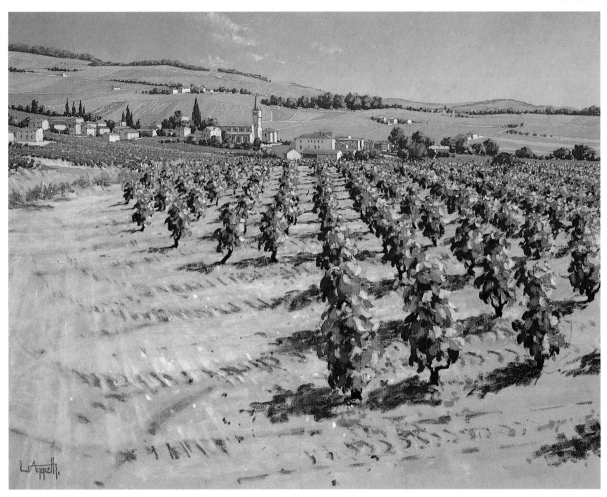

Chénas.

19½ x 25½ in (50 x 65cm).

STAGE 3

I applied the lighter passages to the hillsides, accentuating their form. Tracks and pathways were highlighted using yellow-gold 18, brown earth 7 and red earth 1. The sunlit foliage of the trees was developed still using shaded greens in the distance, working to more saturated colours towards and in the village. Yellow-gold 1, 13, 14, and red earth 15 were blended sparingly. I applied green 8, 9, 10, 11 and yellow-gold 1, 13 to the vines, painting the leaves in a loose manner and building up form working from dark to light. The foreground was then strengthened, increasing the tone of tracks, red earth 5, and lightening the sand where it was compacted, yellow-gold 12, red 18, 12. I then proceeded to take the painting to the heights demanded by the strong mid-morning sunlight by first adding the shadows blue-violet 18, 17, green 2, and yellow-gold 2. I lightened the sunlit surfaces of buildings still further with yellow-gold 12, grey (cream) 17 and red 18 before suggesting the fenestration and adding highlights, chimneys, etc. Green 12 and yellow-gold 12 were used for the lightest vine leaves, and then blue-violet 8, 7 deflected from the sky by turned foliage and smooth surfaces such as packed sand and stones.

PIEDMONT

The Langhe and the Roero are south-east of Turin and roughly midway between this city and the shores of the Mediterranean. The next two subjects are situated in the hills of the Langhe, the more southerly of the two regions.

A pleasant alternation of rounded gentle slopes and small plateaux exists, and the hills overlook valleys teeming with diverse agricultural activity. The Langhe region does of course possess the famous wine-producing localities of Barolo, and Barbaresco where the land is solely cultivated as vineyards. Dovetailed in between these and other intensive wine communities are a mixture of deciduous woodland, crops, cereals, linseed, pasture and, naturally, vineyards. In the early part of the year there is a patchwork of warm vibrant colours, and in the autumn the area is almost afire with colour.

The subject of my Langhe painting was a riot of coloured patterns, like a huge quilt placed over chair-backs to dry. The view seemed to me to possess everything. The composition led me from the vibrant poppies and grass through the wheat and into the landscape amongst radiant red-green, blue-orange and yellow-violet complementary combinations, twisting through to the blue-violet and blue-green distance – and back.

The yellow ripened wheat on the slope in the middle distance, right, forms an important complementary contrast with the blue-violet haze and lower sky above.

The Langhe, near Barolo.
19½ x 25½ in (50 x 65cm).

NOVELLO, THE LANGHE

Not far from Barolo the elevated village of Novello stands proudly overlooking the endeavours of its inhabitants. The sides of these hills with their gently twisting and turning slopes produce exciting multi-point perspectives within the rows of vines. This is exaggerated in quite spectacular fashion early in the summer where young vines have been planted, and the vanishing points of perspective are very pronounced across the warm pink-ochre earth.

STAGE 1

STAGE 1

The essence of this first step was carefully, but lightly to draw the structure using a long thin stick of charcoal to delineate the lines of perspective upon which the vines would later be loosely hung. The clear blue sky was painted first, blending blue-violet 10, 9, 8, 7, blue-green 9, 10, 11, 12 lightening downwards and from right to left, where blue-violet 1 was also applied using the same overlapping flat strokes. The far distance was registered using blue-violet 13, 14, blue-green 5, 6 and a delicate application of blue-violet 1.

The buildings commanding the summit were established through darks (shaded blue-violet) and lights (yellow-golds and reds), before the shaded areas of trees were registered. The stakes in the foreground were added, red earth 6, blue-violet 18, to fix the darkest dark.

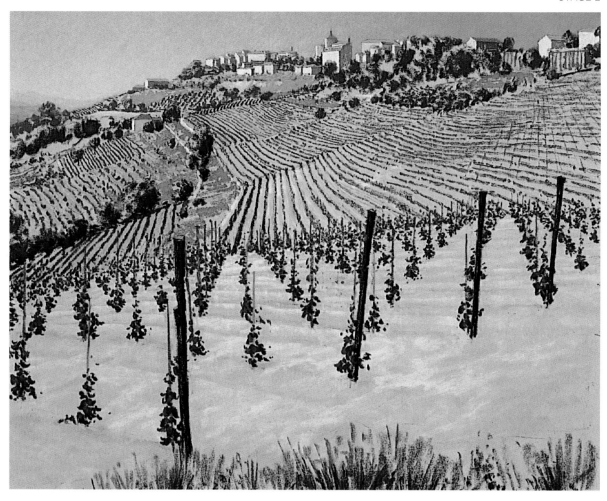

STAGE 2
The structural framework and tonal range of the painting now fixed, I set about establishing the base half-tones and colours of the various forms of vegetation. Mainly unsaturated colours were used at this stage to determine shade and form. Strokes were quite loosely applied, but in an ordered manner expressing the strong linear character of the subject. Reflected light was suggested on the shaded faces of the buildings before I added the roofs, red earth 3, 14, 9, 8, 7, red 16, 17 and brown earth 9, 8, thus registering an important complementary with which to 'cap' the painting.

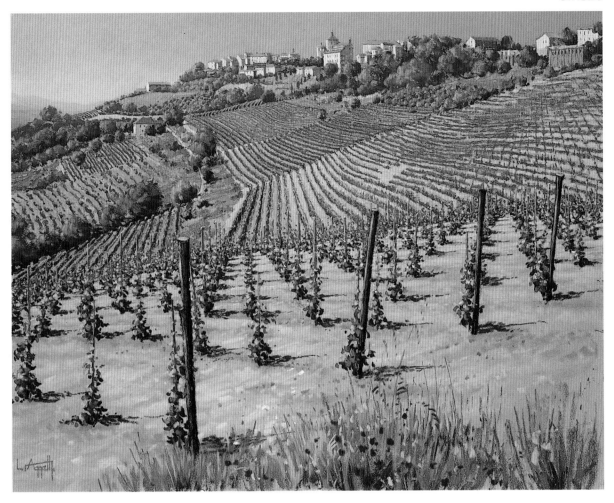

Novello, the Langhe.
19½ x 25½ in (50 x 60cm).

STAGE 3

I developed the foreground earth further by making use of the light oxide-red Rembrandt board, together with broad strokes of brown earth 10, 9, 8, 7, red earth 8, 7, red 18, and yellow-gold 12. The 'body' of trees, vegetation and vines was increased using unsaturated colours in the distance and increasing the saturation towards the foreground. As the intensity of the greens was increased and developed with different colour accents so were the many variations of the red-green combination created.

Even under an intense blue sky such as this, there is hardly a 'pure' unadulterated green to be seen. There are subtle applications of browns, reds, yellows, colours rejected by the chemical properties of the surfaces the light is falling on, and colours reflected and deflected from adjoining areas; from beneath the red-ochres of the earth, and from above the colour of the sky. Finally shadows from the late morning sun, and highlights, particularly to the stakes, were added.

TUSCANY

There is insufficient space here to expound the wonders of Tuscany; best leave the guide-books to do that. There is a distinctive balance between the natural and human world, where magnificent towns seemingly grow out of the tops of hills, surrounded by terraces of vines, olive trees, fruit and vegetables growing in the fertile soil all succoured by a benign climate. There is a tremendous variety of landscape where areas possess a distinctive character of their own.

Some appear almost too 'picturesque' and ordered where the architecture, townscapes and rural activities seem to have fallen out of a Renaissance painting. In contrast, the bleak clay landscape of the Crete below Siena, to the south the Val d'Orcia with its hot springs, and Volterra, west of San Gimignano and perched on a high plateau enclosed by volcanic hills, presents an almost forbidding wilderness. The hills encourage clouds and storms which are quickly over, so the light never stays still.

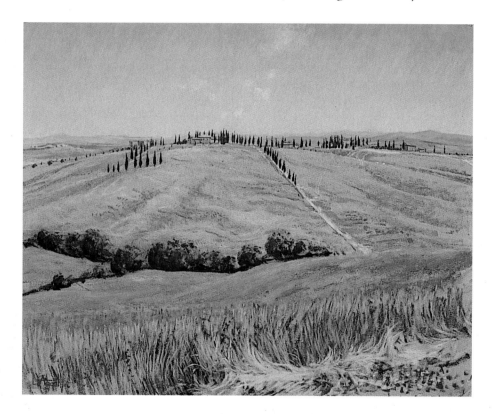

The Crete Senese.
15¾ x 19½ in (40 x 50cm).
Although I was perched beside two solitary poppies there was a carpet of them further to the right. Trees behind them would have concealed this view of cypress trees climbing up the pale clay hillside to the farmhouses at the summit. The Crete is a fabulous, sparsely populated region and this view painted on chrome-green light Rembrandt board is a typical example of the landscape to be found. A study in greens and ochres, I managed to ignore the temptation to move the blanket of poppies across for inclusion in the painting. They would have provided a dramatic contrast, but somehow I felt the subtlety and stillness of the experience would have been lost.

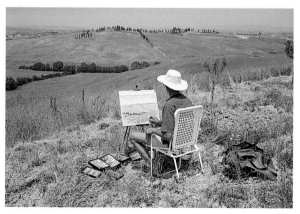

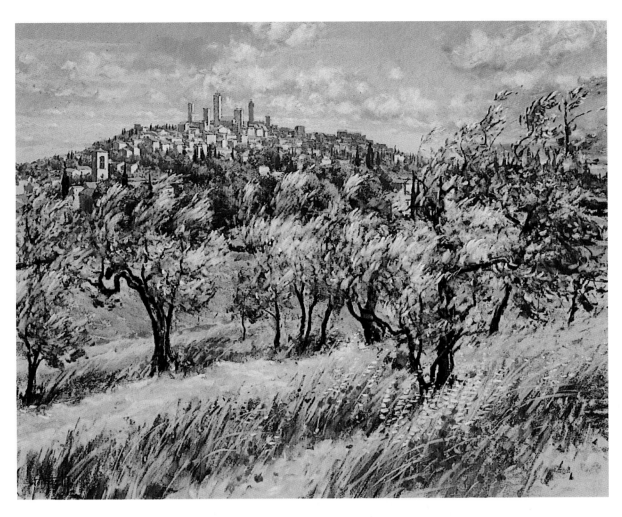

Olive Grove, outside San Gimignano.

19½ x 25½ in (50 x 65cm).

I set myself up on a hillside overlooking the town and surrounded by olive trees. It was quite warm at first but after a while a cool wind started and eventually, as the finished work shows, the foliage was nearly wrestled from the branches by the vigorous onslaught. The lightweight shower-proof jacket helped to keep the wind out! Other measures included suspending a rock from the easel to help steady it. Even so, I had to hold the board firmly throughout.

The clouds were passing fairly quickly at the start so that should have given me some sort of clue, and the olive leaves were soon bending over to display the delightful silvery blue-green of the under leaves. The scurrying

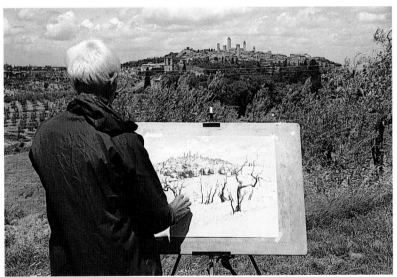

clouds wove patterns of light and shade across the bounding and waving grasses, trees and the distant town. Much deflected light from the sky was record- *ed on the inclined restless surfaces. A memorable session! I used raw sienna Rembrandt board well taped to the drawing board.*

RIGHT **Olives, Vines and Poppies, San Gimignano.**
15¾ x 19½ in (40 x 50cm).
*Collection of Mr and Mrs G D Murrin
The few clouds about the sky cast shadows across the landscape to provide tonal recession. The sunlit vines contrast with the shaded hillside behind. In turn the distant shaded trees on the hill are silhouetted against the sunlit hill beyond, on which stands the stunning 'delle Belle Torri'. San Gimignano is a perfect, well preserved example of a Tuscan medieval hill town. The skyline cluster of towers built by the nobles of the twelfth and thirteenth centuries presents a magnificent spectacle from all angles. Painted on light oxide-red Rembrandt board this view reflects the sentiment expressed in my opening sentences perfectly.*

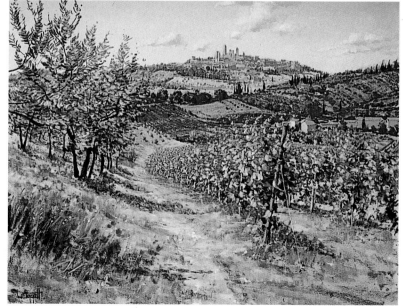

LEFT **Sunset over the River Arno from the Piazzale Michelangelo, Florence.**
19½ x 25½ in (50 x 65cm).
I have produced morning and afternoon studies from Florence's famous viewpoint. From the Piazzale, with its bronze copies of Michelangelo's statues, the entire panorama of the city can be seen. Perhaps the most bewitching time to be there is about an hour before sunset, just looking and waiting for the sun to drop over the Arno. You will be

accompanied by a large and international crowd – great fun!
The painting was produced in my studio on caput mortem red from sketches and a series of photographs. Although full of colour and deflected light, the whole painting is executed with shaded (ie unsaturated) colours. It is often tempting with sunsets to paint too brightly; the strength of light is not, however, sufficient for such extremes. Tonal contrast is important too, in what is essentially a series of graded silhouettes.

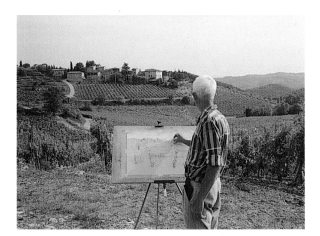

BELOW **Castello di Ama.**
19½ x 25½ in (50 x 65cm).
Another of my favourite spots is the village of Ama, south of Radda which was once a fortification on the southern edge of Florentine territory. One of Chianti's first-rank wine estates, Castello di Ama vineyards are gathered round the village. Made most welcome I came away with a bottle or two of their excellent wine. The Chianti hills are a mixture of woodland and vineyards, and this early-evening view is typical of the terrain. Note how the shadows are lengthening under the warm glow of the early evening sun which fills the upper leaves of the vines with yellow-golds. The vines also deflect the blue-greens and blue-violets in the sky. I used raw sienna Rembrandt board.

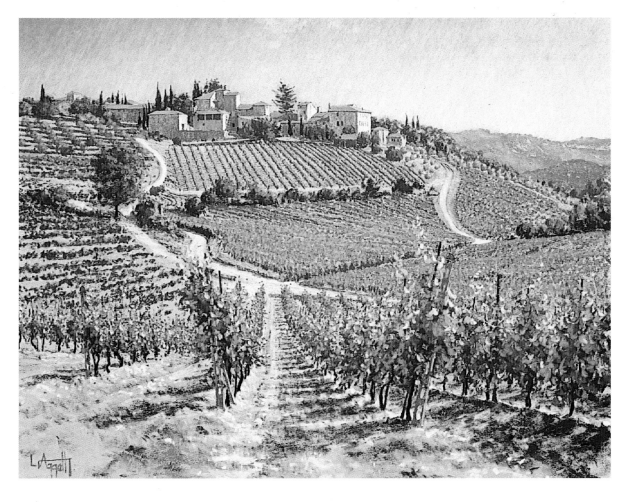

LANDSCAPE BELOW SAN GIMIGNANO

This view from the walls of San Gimignano looks out over a landscape that has hardly changed since the local fourteenth-century poet Folgore was inspired by much the same breathtaking beauty. He was known as 'Lightning' for his speed of thought, but looking at this peaceful scene such a tag must be viewed as relative to the pace of life at that time. The thirteen twelfth- and thirteenth-century towers of this town look impressive enough but considering there were seventy-six 'belli torri' built as fortifications and keeps by the feuding nobles, their height determined by wealth, we can imagine the atmosphere of daily terror that must have existed. No doubt, therefore, Folgore would need to have been fleet of both foot and brain!

Although there are many natural elements within the landscape, the colours, patterns and textures are surely of a grand design, crafted by the naturally gifted Tuscans. Vistas in any direction could be transferred to a wall as the background for a fresco. The artistically arranged olive and cypress trees, Vernaccia vines and poppies intermingling with young grass are convincing enough!

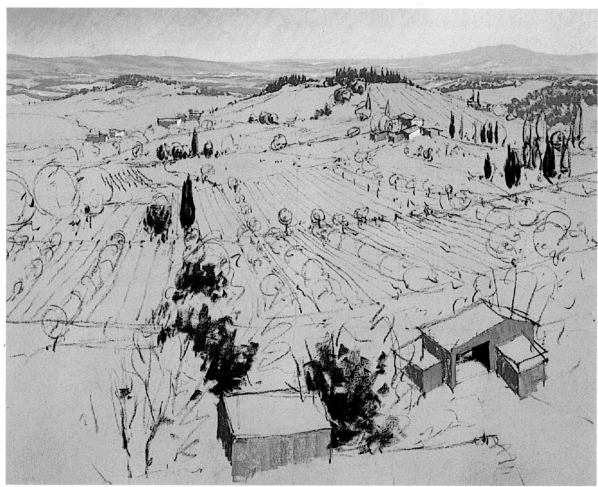

STAGE 1

STAGE 1

I indicated the outline of the composition lightly in charcoal. The perspective of the vines and olives leading away from the town into the surrounding countryside was punctuated by cypress trees and countered by the strong sweeping demarcations of the various plots running across the landscape. The sky, although providing wonderful, clear light, played a minor role. I completed this and then blocked in the distance using blue-violet 13, 14 and blue-green 5, 6 and 17. A few tonal relationships establishing the order of pictorial perspective were recorded from distant trees to those in the foreground, where the darkest dark, red earth 6, green 13 and blue-violet 18, was registered. The shaded and sunlit faces of buildings were painted so that at this early stage the tonal parameters, ie the lightest light and the darkest dark, were fixed.

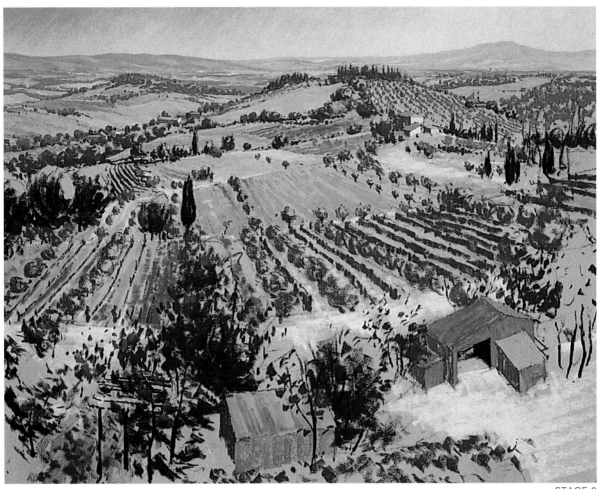

STAGE 2

STAGE 2

Proceeding to establish the groundwork for the fresh early
June colours I used flat strokes to block in areas of colour,
starting with the distant slopes and working backwards out
of the picture. This is how I tend to work, although I appre-
ciate other artists have different ways of approaching a
painting. If you work back from the distance to the fore-
ground with each application you will find it assists in keep-
ing the work clean. Here flat areas of shaded colour were
used to establish the underlying relationships of the various
hues and shaded areas to trees and foliage; this developed
the tonal range and pictorial perspective.

Landscape below San Gimignano.
19½ x 25½ in (50 x 65cm).

STAGE 3 (overleaf)

As the painting progressed I became unhappy with the fore-
ground. Although fairly restrained at the end of the previous
stage, the trees became shapeless and overworked, thus
detracting from the elegant directional simplicity of the land-
scape. There were two cypress trees just off to the left and
so I decided to do a little replanting of my own. Taking my
trusty worn-out bristle brush, I removed the pastel and,
after dabbing the area with a kneaded putty rubber to
remove all dust, I 'slid' the trees and building to the right,
reworking the area as I did so. My little bit of landscaping
retrieved the situation, and although you may consider I
have cheated, the landscape is essentially the same. With
regard to the 'need to be truthful' all I can say is that I have
been honest with you!

Things do not always work out first time, and if there is a
chance of saving a painting then pastel, as you can see, can
be easily corrected. I used raw sienna Rembrandt board for
a painting of an idyllic scene lit by perfect sunlight; one
where complementary colours jostle in their urgency to
reach out to our senses.

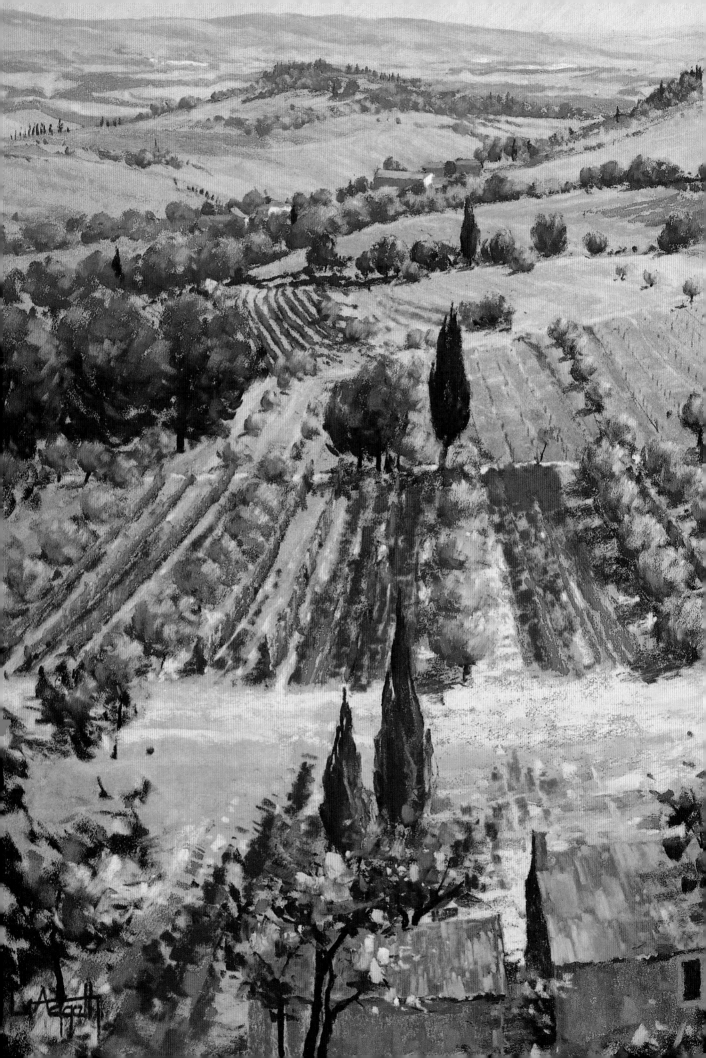

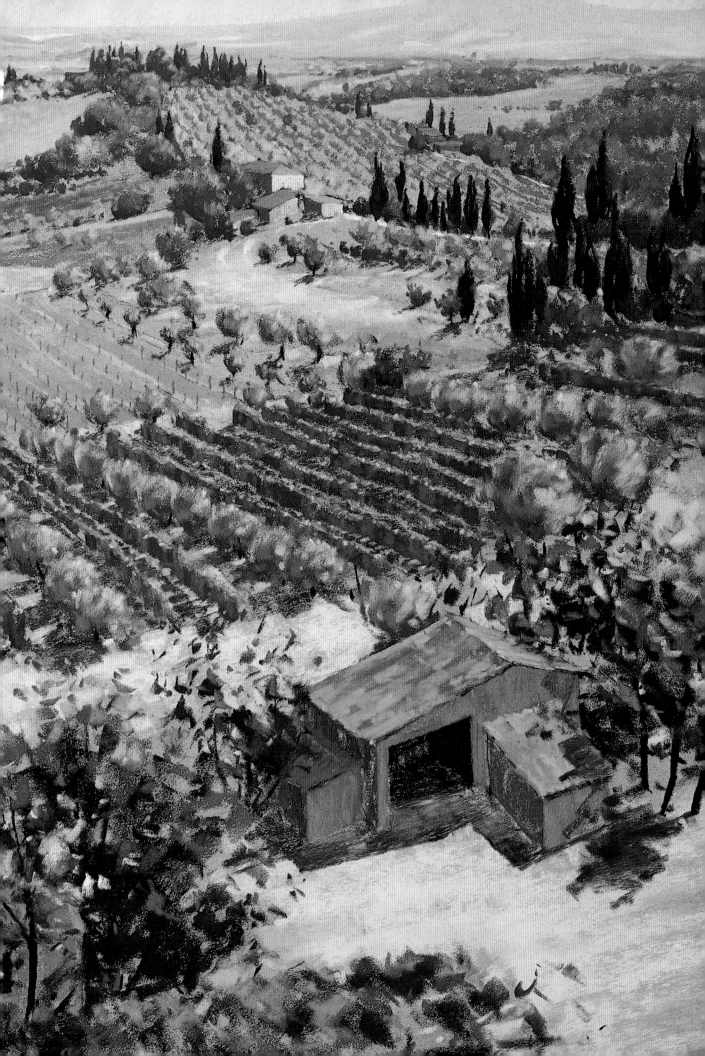

UMBRIA

Known as the green heart of Italy, Umbria is sub-divided by the hills of the Apennines into varied landscapes. The fertile Vale of Spoleto and the rugged valley of the Nera are examples of differing but harmonious beauty. The medieval hill towns are perhaps even more spectacular than those to be found in Tuscany: Gubbio, Perugia, Spoleto, Todi Orvieto, Assisi, Spello, Trevi are all magnificently sited. The air is light and pure allowing clear coloured light to reflect good saturated colour. Such were the weather conditions during my stay in late May, early June at a campsite near Bevagna, a lovely walled town in a quiet backwater renowned for the quality of the nearby olive oil (Montefalco).

On the opposite side of the Vale of Spoleto from Assisi and near to Bevagna lies Limigiano, a classic fortified hamlet centred on a thirteenth-century church, San Michele. Less than a kilo-metre from the spot on the road between Bevagna and Cannara where Saint Francis preached his famous sermon to the birds (there must have been two flocks of birds, for the spot is also commemorated at Assisi's Eremo delle Carceri), the small group of buildings is surrounded by vines and olives. The view shown below, looking almost directly into the evening sunlight, was painted on location, as indeed were many of the paintings illustrated in this section. Being mindful of the tracking sun I aimed for a particular moment in the 'rotation of colour', working speedily to interpret the effect of the light striking through the vines, and casting their shadows towards me. The result, I think, is a fairly bold and spontaneous pastel, produced on raw sienna Rembrandt board.

Limigiano.
19½ x 25½ in (50 x 65cm).

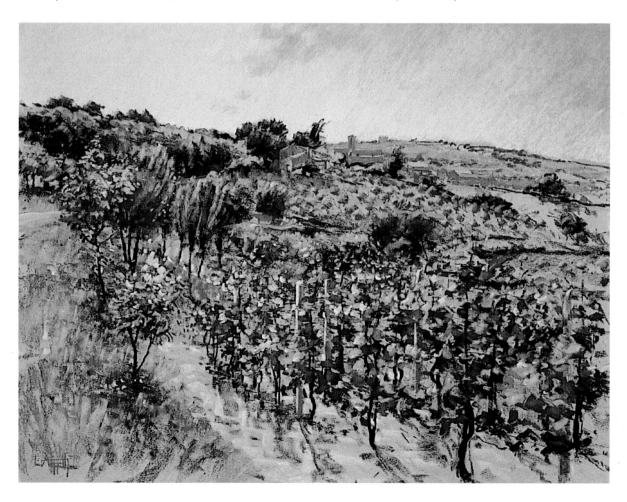

Spello and the Vale of Spoleto.
19½ x 25½ in (50 x 65cm).
Spello, rising in terraces above the Vale of Spoleto, was an important Roman staging post on the Via Flamina. Olive groves behind the town climb northwards towards Monte Subasio. I used raw sienna Rembrandt board for the view painted above right, from the side of the road that runs through the groves, looking back at the town and across the Vale of Spoleto. The evening light sends a warm glow over the tops of the olive trees and creates deep shade beneath. The light and shade of the town contrasts with the sunlit vale beyond. A careful orchestration of tonal values and unsaturated and saturated colours created the pictorial perspective and recession: olives – town – vale.

BELOW **Assisi.**
19½ x 25½ in (50 x 65cm).
Assisi, positioned beneath Monte Subasio on the north-western slopes, presents a magnificent spectacle from the Vale of Spoleto. The tumble of buildings in pinkish stone, surmounted by the Rocca Maggiore with

its turrets and parapets, and culminating at the western end in the immense structure comprising the Upper and Lower Churches of the Basilica di San Francesco, can be seen for miles around. I have painted Assisi from various angles and the view below, through a vineyard flanked by poppies and olive groves, is typical.

The late May morning light radiates through the vines and bathes the poppies and grasses in warm sunshine, releasing saturated complementary colours. The pictorial recession produced by the slight haze, and the linear perspective provided by the vines, poppies and olives gave the subject much depth centred on the basilica. I used light oxide-red Rembrandt board.

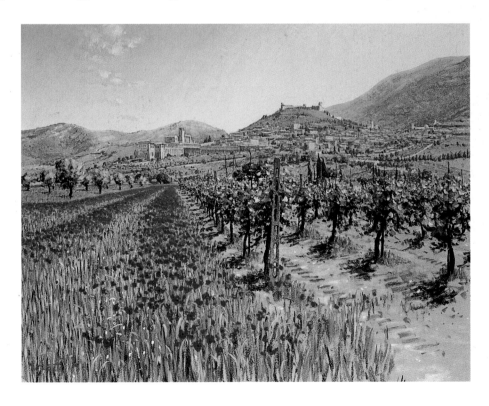

GUALDO CATTÁNEO

There are so many hill towns and villages in Umbria that it would be virtually impossible to find out information about them all prior to visiting the area. General guide–books could not cope with the number; one just has to seek them out. So it was with this little gem, the small fortress town of Gualdo Cattáneo perched high on an outcrop just 5km from Bevagna. Stepped olive groves in narrow terraces climb and cling precariously to the surrounding hillsides, and after scrambling up and over rocks I eventually settled myself amongst the olives and poppies to record this view which was finally painted in the studio.

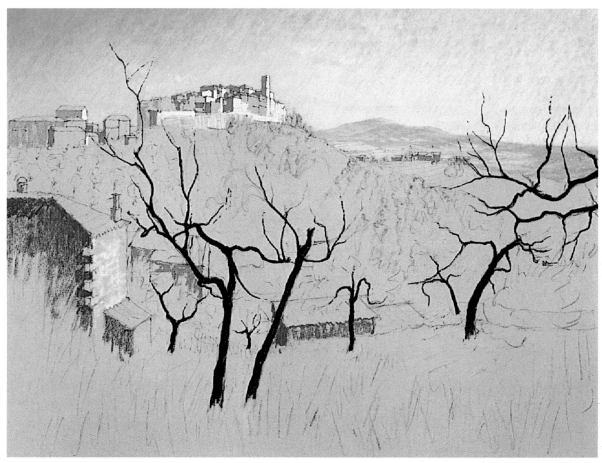

STAGE 1

STAGE 1
I very lightly drew the outline of the composition on light oxide-red Rembrandt board before pastelling the blue sky using blue-violets and blue-greens. I kept the strokes fairly open, that is to say without blending too much. I introduced yellow-gold 12 to the right, the direction of the sun, and blue-violet 1 on the left suggesting the slight haze, again placing strokes side-by-side without too much overlapping. The faint clouds, blue-violet 13, 14, 1, yellow-gold 18, grey (cream) 17 and red 18, were painted in the same way. This produced a shimmering resonance which I hoped would run through the whole painting. The distant hills were registered with flat strokes of blue-violet 13, 14 and blue-green 5, 6.

The dark trunks of the olive trees were indicated with red earth 6 and blue-violet 18 thus fixing the darkest dark. I then established the strong form of the town with shade and light, blue-violet 13, 14, 15 and yellow-gold 18, red 18. The shaded and sunlit faces of the foreground buildings were also blocked in with flat strokes, to set the tonal and compositional arrangement.

STAGE 2
I suggested detail in the far distance by indicating sunlit areas, blue-green 18, 6 and green earth 13. The remaining shaded elements of the middle distance were then added. The qualities of perspective produced by the olive and deciduous trees formed an important visual link between foreground and town. Shaded blue-greens, blue-violets, greens, and green earths were used at this stage. The roofs were added to the buildings of the town using brown earth 9, 8, 7 and red earth 3, 7, 8. I then indicated the

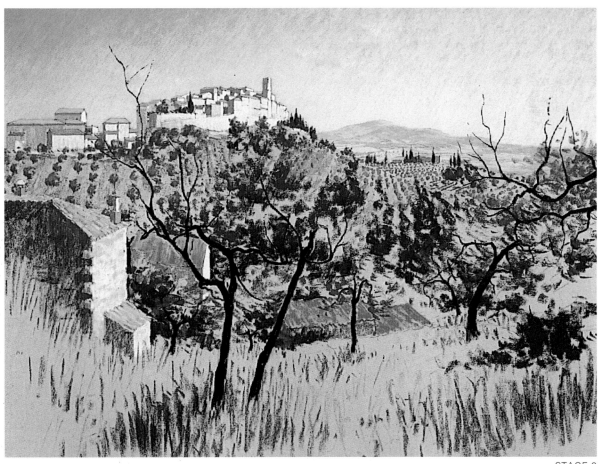

STAGE 2

shaded foliage of the olive trees, green 13, 14, green earth 18 and blue-violet 18. Green 13 and blue-violet 18 were also used to suggest the shaded grass. Areas of light and shade were thus determined before developing the nearer farm buildings.

STAGE 3 (overleaf)
Starting with the town I proceeded to work out of the painting by first suggesting the fenestration of the buildings and the odd detail or two, eg chimneys etc, taking care not to overdo things. Working from dark to light, I developed the grass, earth and trees in the middle distance. Detail was suggested to the farm buildings with broad strokes before working on the lower olive trees, building up the shaded areas that would eventually form a contrast with the sunlit foliage of the foreground trees. I tackled these next, work-

ing towards the lighter shades, green 15, green earth 12, 11, 10, 8. The grassed area was brought to life with flat and line strokes using green 2, 7, 8, 9 and then brown earth 9, 7, yellow-gold 13, 14, 17 and 8, 10, 12 for the ripe, lighter areas. Shadows were added, using blue-violet 18, 17, 16, decreasing in tone as distances increased.

The poppies were then added with unsaturated red 13, 15 and saturated red 8, 9, 10, 11. Suggested details such as the nearer grasses and seed heads were pastelled with swift crisp strokes before highlights were applied to the olive foliage, blue-green 18, yellow-gold 12 and red 12. Finally, delicate touches of blue-violet 8 were added sparingly to capture the deflected light from the sky.

Gualdo Cattáneo.
19½ x 25½ in (50 x 65cm).

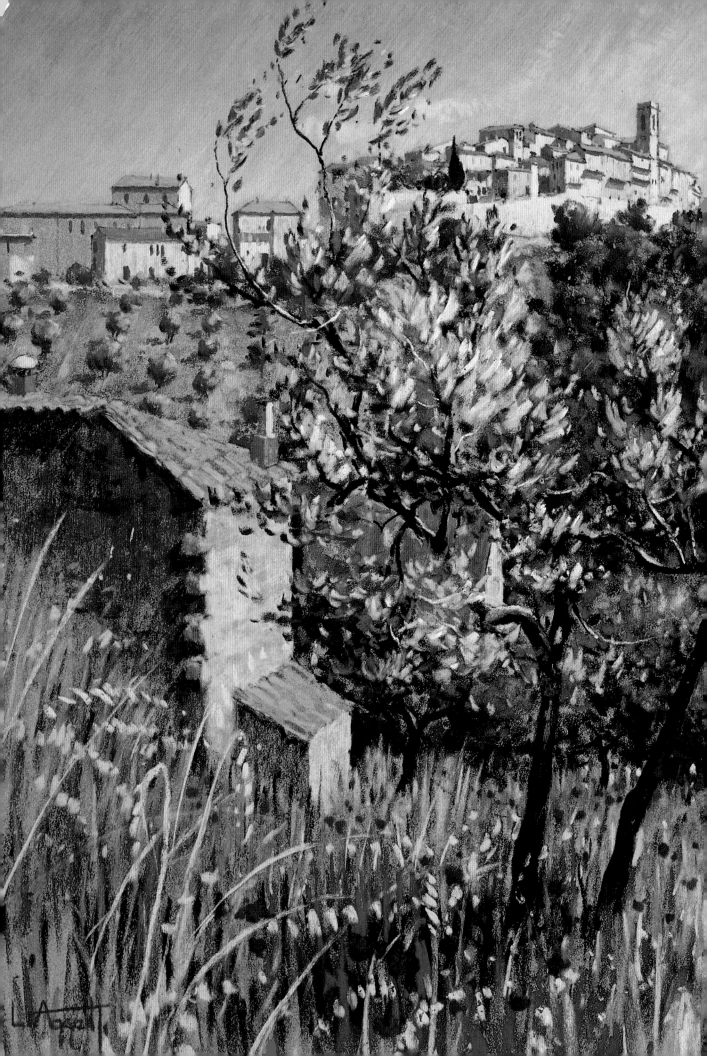

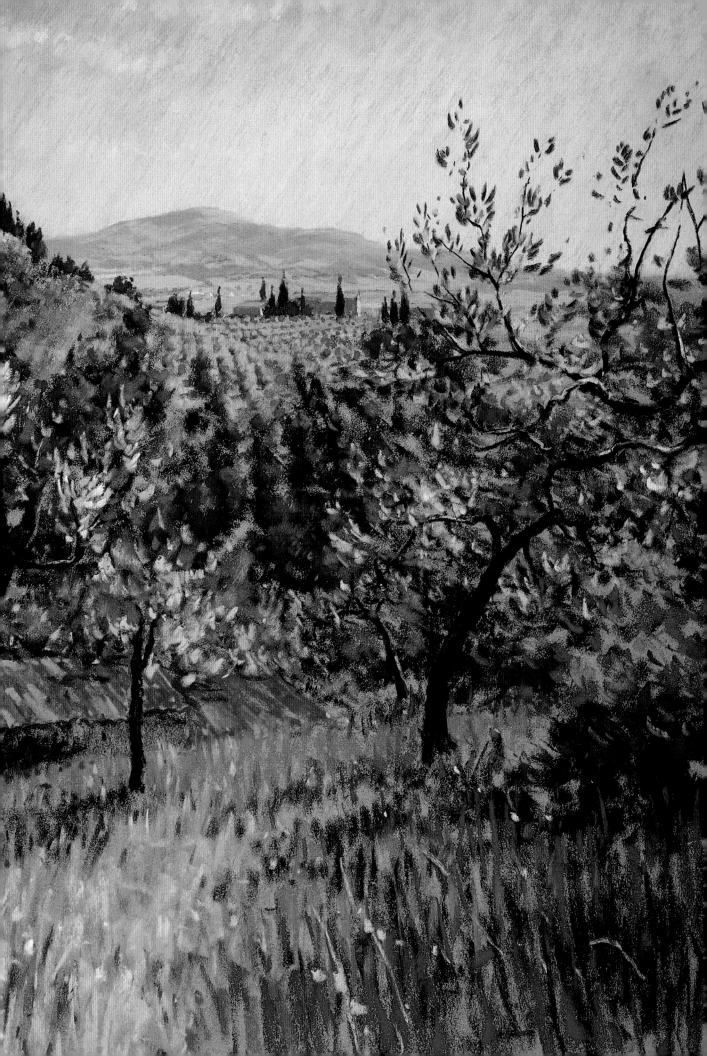

PROVENCE

I still have much to discover in this very varied region where the constant factor is the quality of light. There are, even so, subtle changes in the vibrancy – the extent of which is dependent on the local terrain. As with other regions, time produces a rotational change. So even here, where the clarity is the greatest of the regions discussed, light is always changing.

The varied landscape is due to the diversity of its geological formation. Flat deserts, dry hills and rugged mountain peaks contrast with well watered valleys of lush vegetation. I have been drawn time and time again to the Vaucluse, Lubéron and Les Alpilles areas where hill villages and towns, olive groves, almonds, peaches, cherries, vineyards, sunflowers, lavender, red and yellow-ochre earths, and white rocks reflect clear colours under the constantly moving sun. More recently, as some of the paintings in the book show, I have worked in the area bounded to the north by the Baronnies.

One of our favourite haunts is the landscape around the Coulon Valley overlooked by four magnificent *villages perchés*: Lacoste, Gordes, Rousillon and Bonnieux. Stand at the summit of any one, and you are able to look across beautiful countryside to see the remaining three.

At springtime the cherry orchards surrounding Bonnieux on the three sides (for the village stands at the end of a spur of the Lubéron Hills) is an unforgettable sight. In full bloom the trees scintillate with a myriad of deflected colour under the already hot morning sun. The petals are not white but assume subtle variations of the colours around them. The colour of the sky is also deflected by the multifarious surfaces. I used a full sheet of Canson Mi-Teintes 340 for this painting.

Cherry Orchard, below Bonnieux, Provence.
21¾ x 29½ in (55 x 75cm).
Collection of Mr and Mrs John Flower

RIGHT **Olive Grove, Les Alpilles.**
12¾ x 17 in (32.5 x 43.5cm).
Les Alpilles, the small range of hills painted by Van Gogh, is a dry hot place in high summer. The sun almost bleaches out all colour with the intensity of the ultraviolet rays and searing heat. These are challenging conditions under which to paint, as uncomfortable in their way as a session on Dartmoor in early February.

The silvery blue-green of the olive foliage is heightened by the colour deflected from the sky off the surfaces of the leaves, turned by the hot faint breeze. I chose light oxide-red Rembrandt paper, providing a suitable ground for the pink-ochre sandy soil.

BELOW **Le Circuit de Vaucluse, Rousillon, Provence.**
19½ x 25½ in (50 x 65cm).
Private collection
Le Circuit de Vaucluse is one of the early major races of the season which feature top international riders. This particular race did not appear to have quite the same following as the Tour de France but this may have been because it was bitterly cold. The mid-March mistral whistled through the village and it really took an effort to sketch and paint that day. This painting is from a photograph taken while I was working on a painting near the square on the left. We had plenty of notice to be in position – the entourage, including forward police motorcycle outriders, took about an hour to pass!

Although it was extremely cold the clear sunshine drew out the warm and saturated colours of the ochre buildings and brightly clad cyclists. I used light oxide-red Rembrandt board for the painting completed in the studio.

AU MILIEU DES LAVANDES

The measure of Provençal light and heat is intensified in this view of lavender on the edge of the Vaucluse plateau. The rogue sunflowers, late stragglers, with the lowering sun shining directly through their upper petals, form a vibrant complementary contrast with the lavender. Accompanying this blue–violet–yellow combination, further and more subtle secondary and primary duets of orange–blue and green–red are illuminated by a yellow–green sky. The visible lowering sun produces dark and light passages of great depth. Light is deflected off the edge of all silhouetted form in shimmering and vibrant contrast.

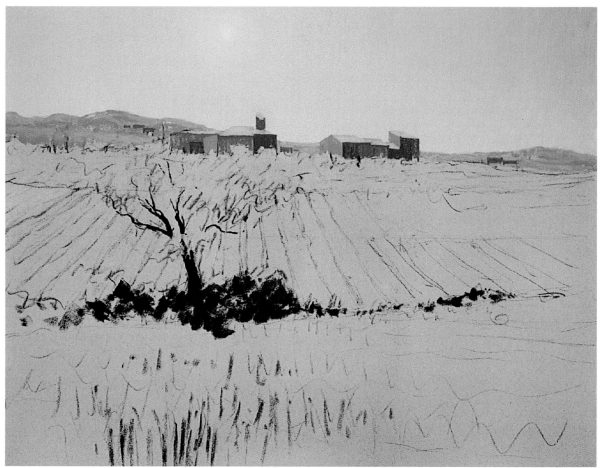

STAGE 1

STAGE 1
After roughly indicating the composition in charcoal on raw sienna Rembrandt board, I tackled the sky. Positioning the sun with yellow-gold 12 and grey (cream) 17, I then started working in from the periphery with blue-violet 7, 8 and blue-green 11, 12 applied with flat strokes rotating around the sun, and lightening towards the sun. I then worked out from the light source using yellow-gold 12 in the same manner, carefully blending the colours over one another. The distant hills were registered with blue-violet 13, 14 and blue-green 5 and 6 before I fixed the darkest dark, red earth 6 and blue-violet 18, to the trunk of the tree in the foreground. Shaded mid-tones were then applied to the walls of the buildings, blue-violet 12, 14, 15, 16.

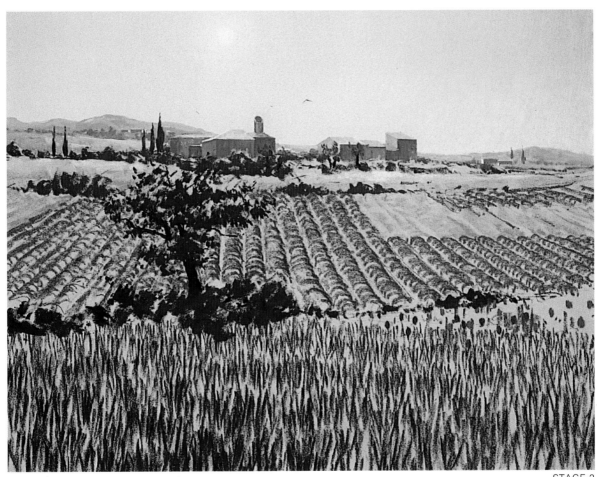

STAGE 2

I returned to the distance, adding trees with blue-green 4, before laying in the darks to the trees and foliage along the ridge using blue-green 1, 2, blue-violet 17, 6 and green 1, 2. Darks added to the foliage of the foreground tree and hedge were registered with flat strokes, following the form and using these colours with the addition of blue-violet 18 and green 13. The roofs of the 'mas' were added with red earth 3, 2, 14 and 13. I then indicated the lavender with shaded blue-violet 18, 5, 6 describing the form, the further field with its rigid humped lines, and the more random arrangement in the foreground looking across the rows of lavender. The lighter passages in front of the buildings were blocked in with red earth 14, 13 and the crops were added using yellow-gold 14, 15.

Au Milieu des Lavandes.

19½ x 25½ in (50 x 65cm).

STAGE 3 (overleaf)

I suggested a few details to the buildings, openings, shutters and chimneys etc., and then built up the form of the foliage with green 14, 15 and 2. I then turned my attention to the lavender, working from dark to light with blue-violet 6, 5, 4, 3, 2, 1, red 3, 4, 5, green 2, 9 and green earth 12, 11. The sunflowers were pastelled with red earth 16, 7, yellow-gold 1, 13, 7, 9, 10, 12, and green 2, 7, 9 and 11. Sunlit areas were added to the foliage of trees and bushes, indicating reflected light, and the deflected yellow-green colour of the sky. Finally, the extreme highlights were applied to foliage and the lavender with yellow-gold 12.

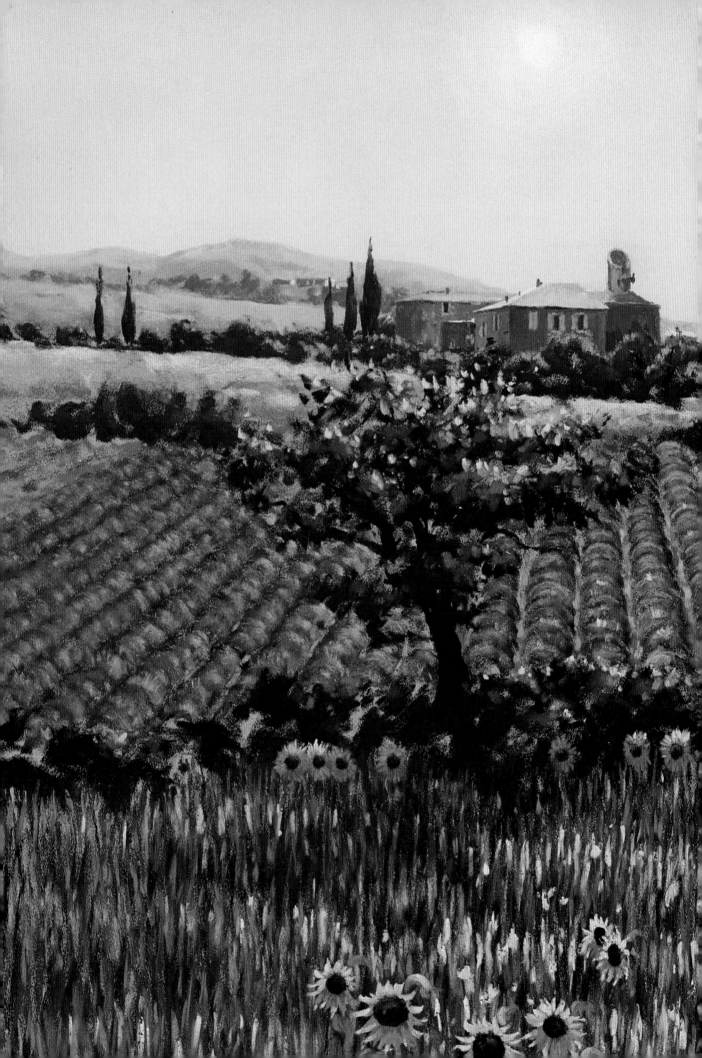

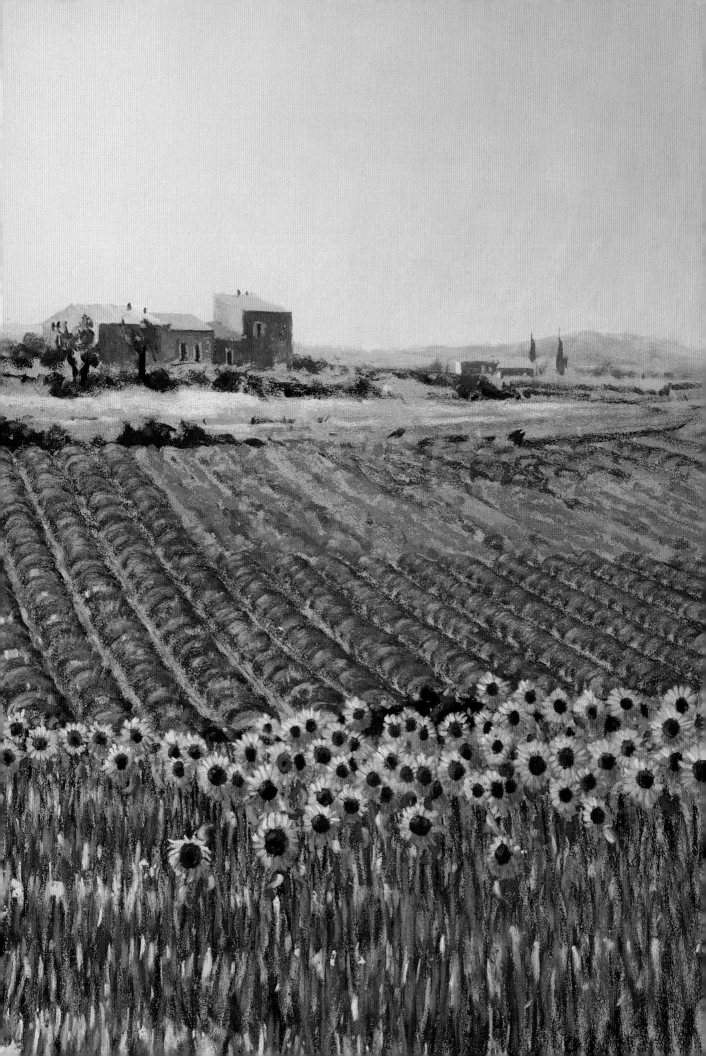

CONCLUSION

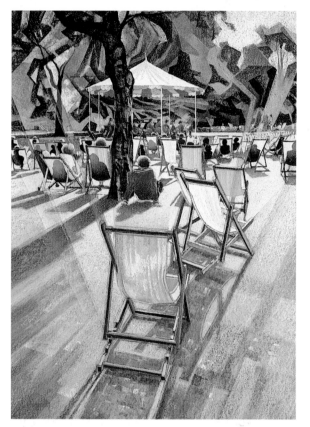

Close observation and the experience of working in the field will ultimately increase our understanding of the various effects produced by the ever-changing light. I would urge you to work outside, painting directly from Nature, as often as you can, for it is only through first-hand experience that you will be able to respond to light on the turn. You may make a few mistakes at first, but quite soon you will find that even the roughest and most brief attempts to catch the light will produce lively and spontaneous results. It is only by working in this manner that you will be able to transport this freshness to your work inside with truthfulness, when, for whatever reason, you are confined to the studio.

In time we may seek other ways of expressing light on 'canvas'. In conclusion, therefore, I offer some examples of my experimental work which I occasionally produce in parallel with my on-site and 'free' studio painting. It involves a rather different approach, more considered perhaps and with a greater element of design, although all painting is directed through one avenue of design or another, whether the work

ABOVE **Overture St James.**
29½ x 21¾ in (75 x 55cm).
Exhibited RWA and The Pastel Society.
Collection of Mr and Mrs B Reeves

RIGHT **Sunflowers below Bonnieux, Provence.**
21¾ x 29½ in (55 x 75cm).
Collection of Mr and Mrs C Rowlands

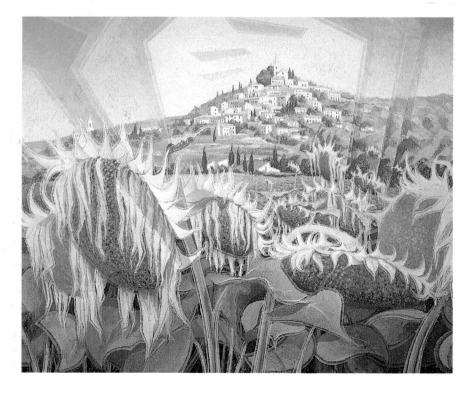

is figurative or abstract. It is good sometimes to take a short break from the mainstream of your creative thinking and work laterally. The change should encourage rather than inhibit your development.

There is still much to be experienced and captured in Nature's presence, however, and there is no better way of describing the thrill experienced when picking up the gauntlet during an open-air confrontation than expressing it through pastel or paint.

ABOVE **Garden Poppies.**
21¾ x 29½ in (55 x 75cm).
Private collection

RIGHT **Evening, St James's Park.**
29½ x 21¾ in (75 x 55cm).
Collection of Mr and Mrs Stephen Sims

Summer Evening, Crediton.
21¼ x 29½ in (55 x 75cm).
*Commissioned by the Crediton
St Boniface Society for presentation to
the people of Dokkum, Holland.*

INDEX